Sault Ste. Marie Ontario in Colour Photos, Saving Our History One Photo at a Time

Photography
by Barbara Raué
2017

Series Name:
Cruising Ontario

Book 171: Sault Ste. Marie

Cover photo: 115 Upton Road, Page 44

Series Name: Cruising Ontario
The Authority on Saving Our History One Photo at a Time in colour photos

Books Available in Alphabetical Order:
Aberfoyle, Acton, Alton, Amherstburg, Ancaster, Arthur, Aylmer, Ayr, Bloomingdale, Brantford, Burlington, Caledon, Caledonia, Cambridge, Clifford, Conestogo, Delhi, Dorchester to Aylmer, Drayton, Drumbo, Dundas, Eden Mills, Elmira, Elora, Essex, Fergus, Guelph, Hagersville, Hamilton, Hanover, Harriston, Hespeler, Jarvis, Kingston, Kingsville, Kitchener, Linwood, Listowel, London, Lucknow, Mono, Mount Forest, Neustadt, New Hamburg, Niagara-on-the-Lake, Oakville, Orangeville, Orillia, Owen Sound, Palmerston, Peterborough, Petrolia, Port Elgin, Preston, Rockwood, Sarnia, Seaforth, Sheffield, Shelburne, Simcoe, Southampton, St. Jacobs, St. Marys, St. Thomas, Stoney Creek, Stratford, Thamesford, Tillsonburg, Waterdown, Waterford, Waterloo, Welland, Wellesley, Windsor, Wingham, Woodstock

Book 125-127: Woodstock
Book 128: Thamesford
Book 129-132: St. Marys
Book 133-136: Sarnia
Book 137: Petrolia
Book 138-139: Welland
Book 140-145: Kingston
Book 146-149: Ottawa
Book 150-151: Midland
Book 152: Penetanguishene
Book 153: Kemptville
Book 154: Cornwall
Book 155: Mariatown to Maitland
Book 156: Morrisburg
Book 157: Brockville
Book 158: Merrickville
Book 159: Smiths Falls
Book 160: Portland, Newboro
Book 161: Westport & Area
Book 162: Perth
Book 163-166: Belleville
Book 167-168: Port Colborne
Book 169: Erin in Colour
Book 170: Goderich in Colour
Book 171: Sault Ste. Marie

Other Books by Barbara Raue

Coins of Gold

Arrows, Indians and Love

The Life and Times of Barbara
Volume 1: Inventions That Have Enhanced My Life
Volume 2: Entertainment That I Have Enjoyed
Volume 3: East Coast Trips
Volume 4: Olympics Have Always Intrigued Me
Volume 5: Wonders of the World
Volume 6: Caribbean Cruises We Have Enjoyed
Volume 7: Animals
Volume 8: Storms and Other Major Disasters in My Lifetime
Volume 9: Wars, Terrorist Attacks and Major Disasters

The Cromwell Family Book

Laura Secord Discovered

Daddy Where Are You?

Montana Series
Book 1: Montana Dream
Book 2: Life on the Montana Frontier
Book 3: Montana to Boston and Back

Visit Barbara's website to view all of her books
http://barbararaue.ca

Table of Contents

Huron Street	Page 7
Queen Street East	Page 12
Herrick Street	Page 51
Kensington Terrace	Page 52
MacGregor Avenue	Page 54
Bay Street	Page 56
East Bruce Street	Page 60
Brock Street	Page 61
East Street	Page 62
Albert Street	Page 64
Spring Street	Page 65
Pim Street	Page 66
Architectural Terms	Page 68
Building Styles	Page 72

Sault Ste. Marie is a city on the St. Marys River close to the US-Canada border. To the south, across the river, is the United States and the city of Sault Ste. Marie, Michigan. These two communities were one city until a treaty after the War of 1812 established the border between Canada and the United States in this area at the St. Mary's River. Today the two cities are joined by the International Bridge. Shipping traffic in the Great Lakes system bypasses the Saint Mary's Rapids via the American Soo Locks, the world's busiest canal in terms of tonnage that passes through it, while smaller recreational and tour boats use the Canadian Sault Ste. Marie Canal.

Before there was a Soo Locks, or even houses and stores, the place we call "the Sault" was a land covered by trees. The people living in this place called themselves "Anishinabeg," which means "The People." They were Woodland Indians whose homes, clothing, food and tools were all made from the plants and animals they found in the woods and water around them. Where the Soo Locks are today, the river that we now call the St. Marys had huge rocks scattered across it.

French colonists referred to the rapids on the river as *Les Saults de Ste. Marie* and the village name was derived from that. The rapids and cascades of the St. Mary's River descend more than twenty feet from the level of Lake Superior to the level of the lower lakes.

Each spring several large canoes paddled by men from the Montreal area called voyageurs came to the Sault from Montreal. With the voyageurs, came traders from the large fur companies of Montreal and tons of goods to be traded for the furs that the Chippewas had trapped during the winter. Among the trade goods were guns, metal knives and traps, pots and pans, blankets, beads and cotton material. Beaver furs were used to make fashionable men's hats in Europe.

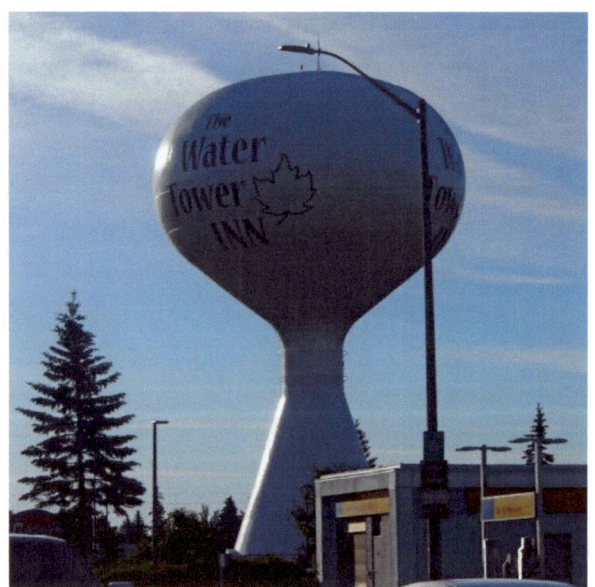

360 Great Northern Road - The Water Tower Inn

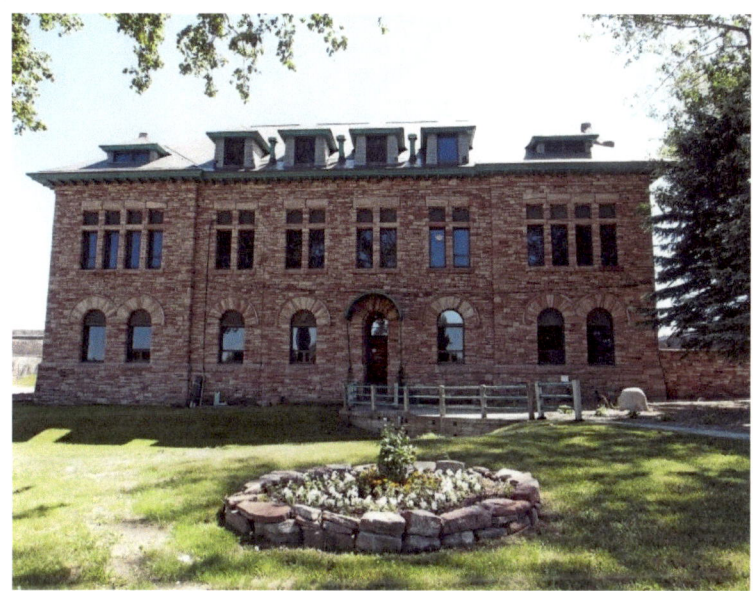

75 Huron Street – Consolidated Lake Superior Company General Office Building (now St. Marys Paper Inc.) – built at the turn of the century in Richardsonian Romanesque industrial architecture with round arched openings and massive rough faced masonry

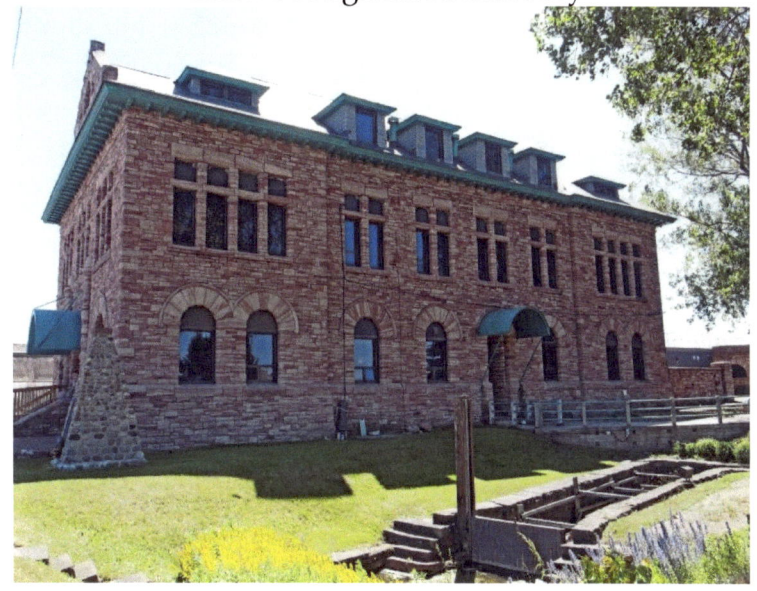

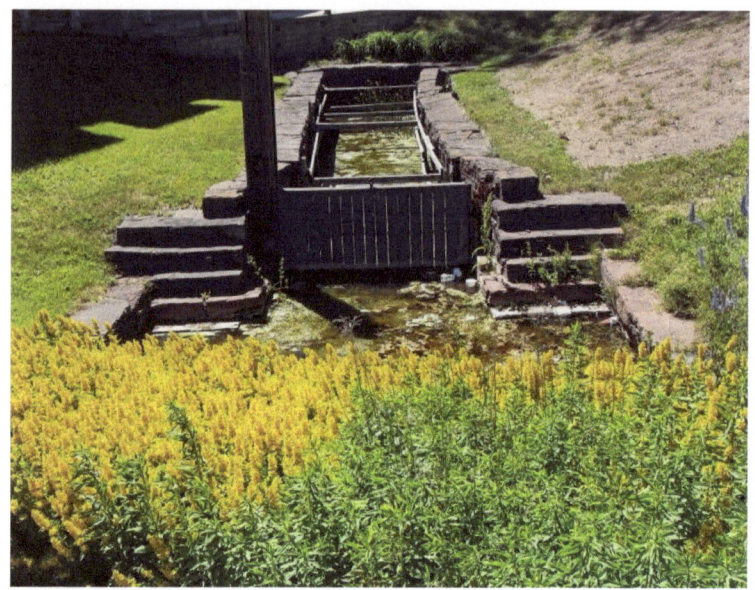

The North West Company Lock was built in 1896 as a replica of the original lock built on the site of the North West Company in 1797. The replica is about forty feet by nine feet with stone walls and miniature head and tail gates. It was built by Francis Hector Clergue, an American entrepreneur who was instrumental in transforming Sault Ste. Marie into a modern industrial town. The original lock was part of a water system that consisted of 2,580 feet of canal and a lock which was designed to raise or lower the fur trader's bateaux by nine feet to get around the rapids on the St. Mary's River.

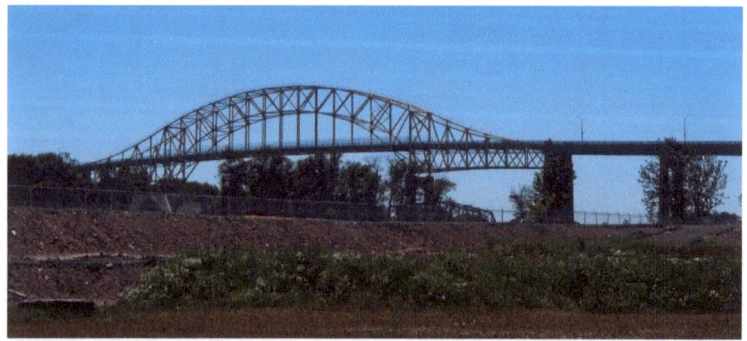

Old buildings by the bridge

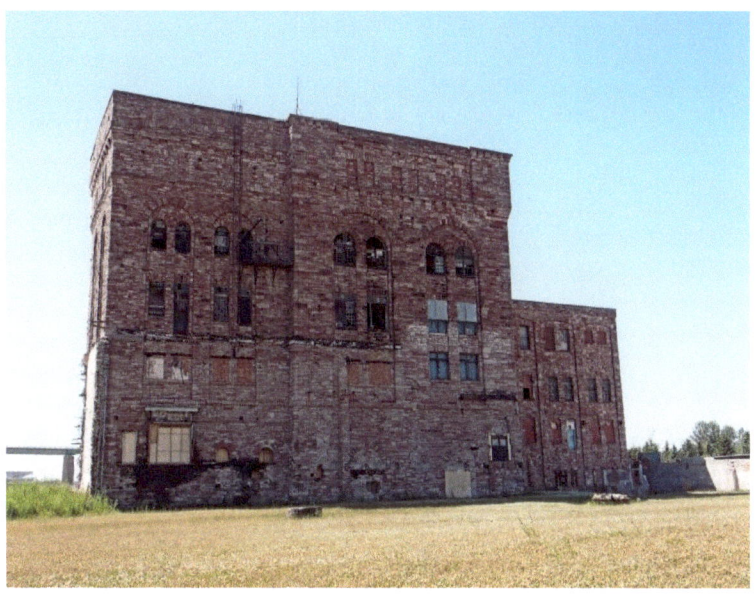

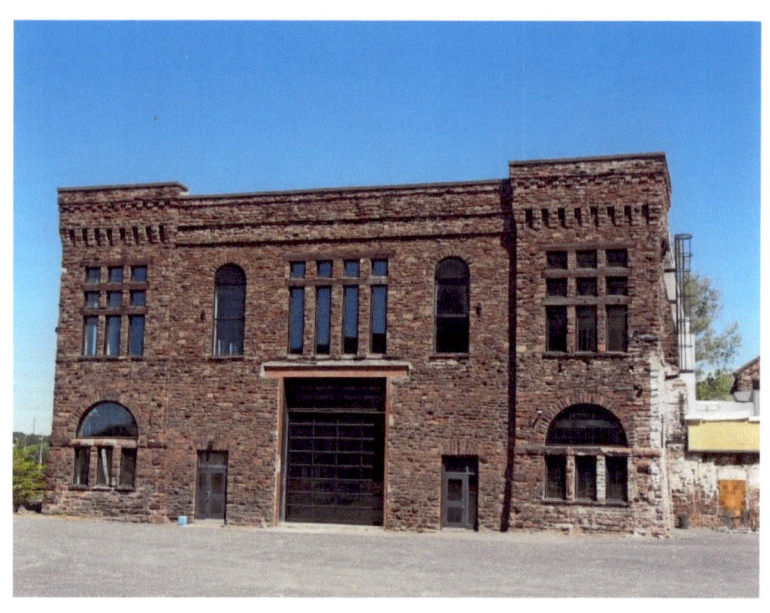

Huron Street

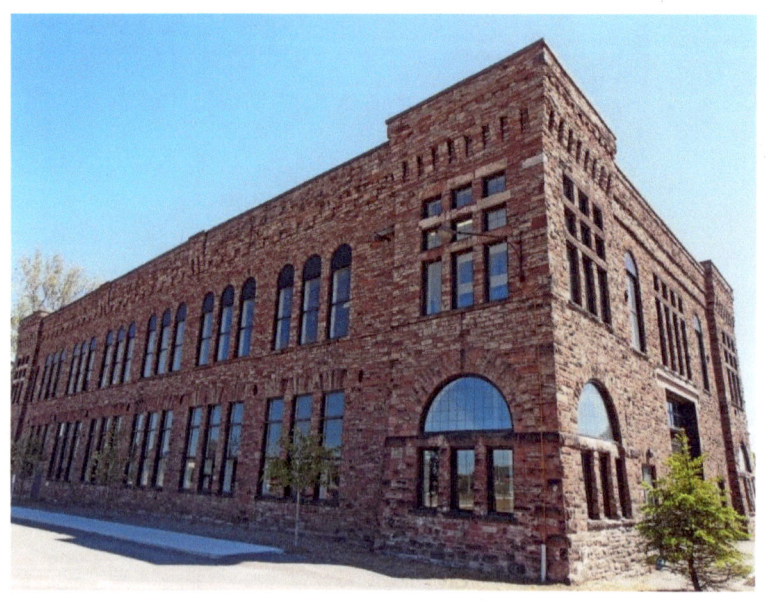

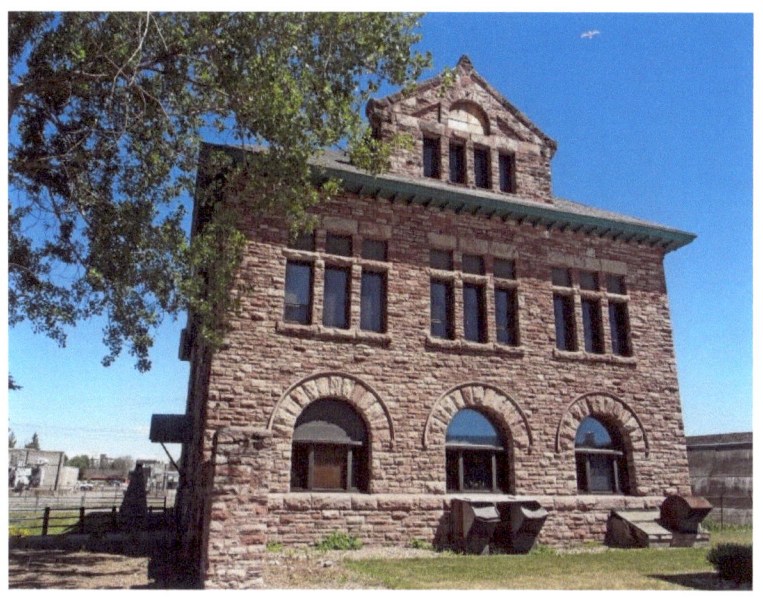

83 Huron Street – The Machine Shop established 1899

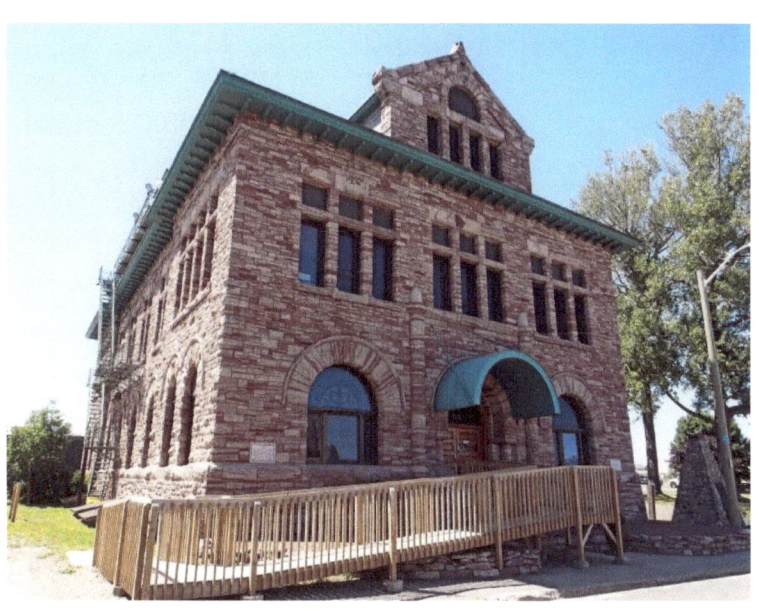

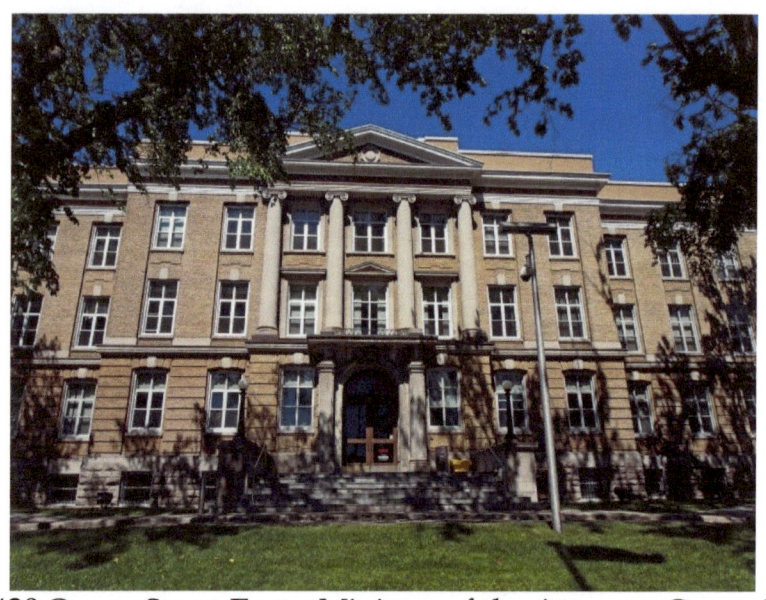

420 Queen Street East – Ministry of the Attorney General Court House was completed in 1922 in the Beaux Arts Classical style. It shows fine workmanship, good material and attention to details. The imposing, symmetrical, three-storey structure is built of orange-brown stone and brick. It is set back from the street on an elevated site and approached by a circular driveway. Its temple front facade consists of Ionic columns supporting a brick pediment.

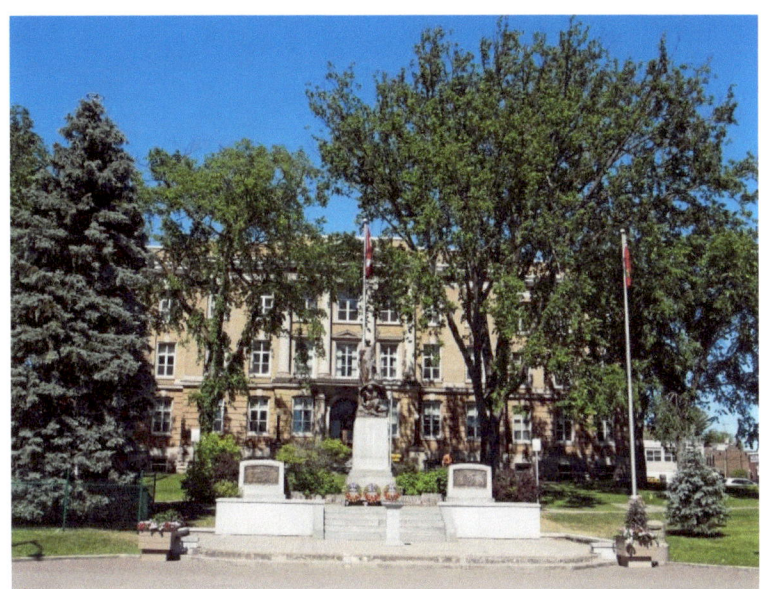

The Cenotaph commemorates the sacrifice of local soldiers in the First, Second and Korean Wars. The central bronze sculpture group depicts War as a crouching male under a shield of Right represented by a draped female holding a sword and a sprig of maple leaves. Side panels depict men answering the call to arms and soldiers helping the wounded.

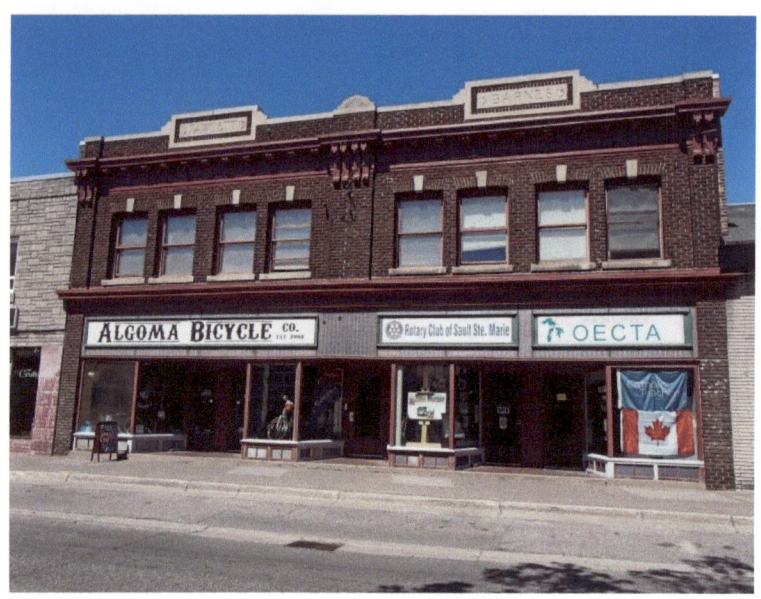

358-360 Queen Street East - Erected in 1913, the two storey brick Barnes-Fawcett Block has five street-front entrances opening onto Queen Street East. Theron T. Barnes was a successful druggist whose original drug store in the Barnes Block had prospered for eleven years prior to the construction on the Barnes-Fawcett Block where he opened a second drug store. Another Sault Ste. Marie entrepreneur, S. W. Fawcett owned a portion of the property at the time of the development. Designed as a matched pair of buildings, with separate identities appearing on the pediment panels, the Barnes-Fawcett Block was constructed as a single structure, housing two stores on the ground floor and offices on the second. The buildings are well proportioned, symmetrically designed, handsomely modelled. The building is in the Classical Revival style. Character defining elements include the 'Barnes' and 'Fawcett' pediment panels on the front façade, two sets of two symmetrically designed storefronts, accessed at the street level through shared entrances, a central entrance accessing the stairs to the second floor offices, two pairs of

windows symmetrically located on both buildings for the second floor offices, symmetrical brackets and large dentils accentuating the cornice and frieze. There are projecting and non-projecting pilasters accentuating the overall design of a matched pair of brick clad buildings. There are stone sills and keystones, modillions and lettering, and a large entablature over the storefronts; ready-made for store signage.

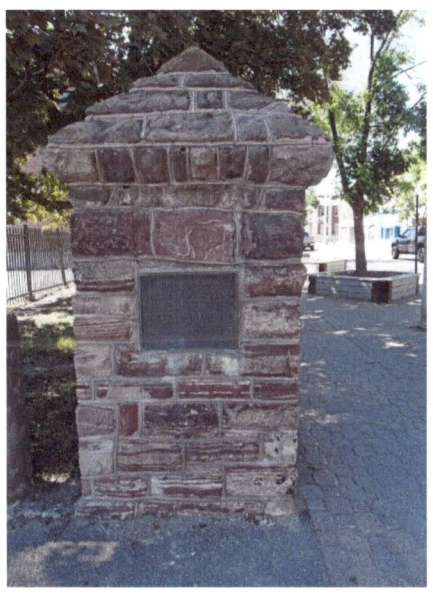

The 225 room International Hotel completed in 1888 reflected the growth of the town which has been spurred on by the coming of the Canadian Pacific Railway and the construction of the International Railway Bridge in 1887. Close to St. Mary's River, the main transportation route, the hotel had its own wharf for tourist vessels and excellent fishing outside the hotel doors. The hotel was completely destroyed by fire on January 10, 1916. Today only the corner post of the stone wall that surrounded the hotel remains.

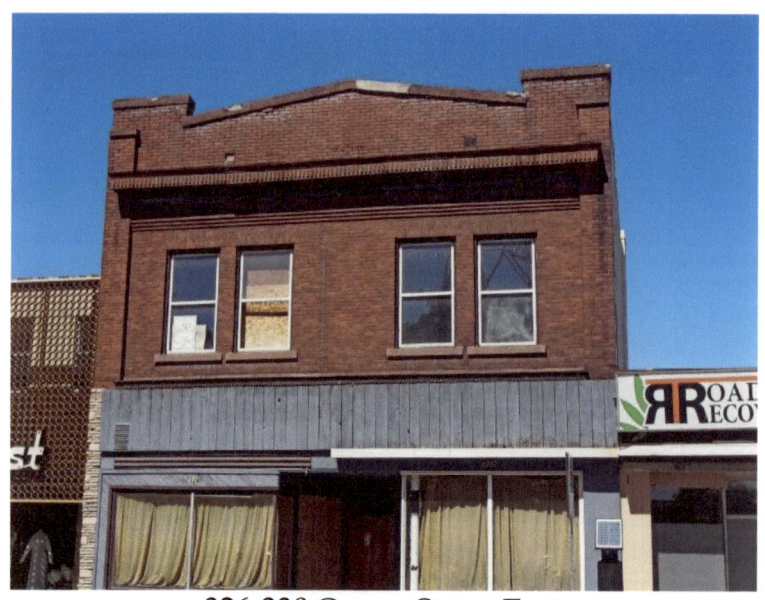

326-330 Queen Street East

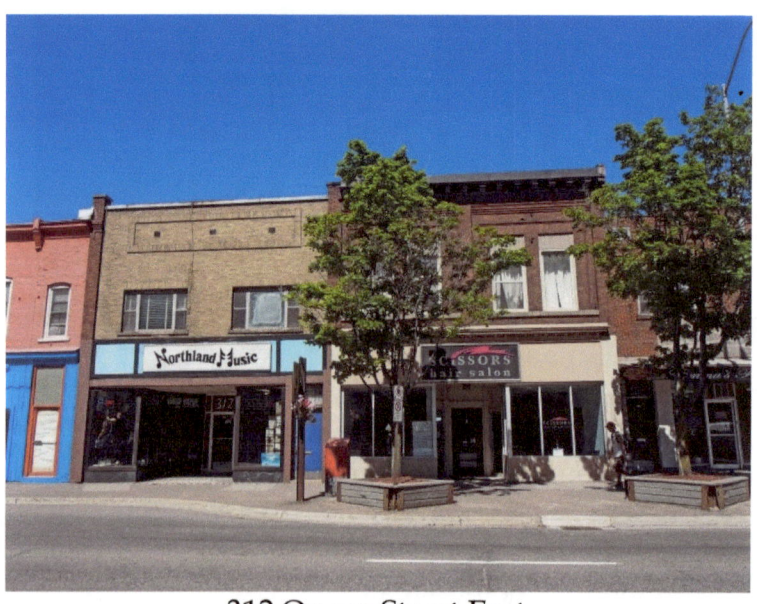

312 Queen Street East

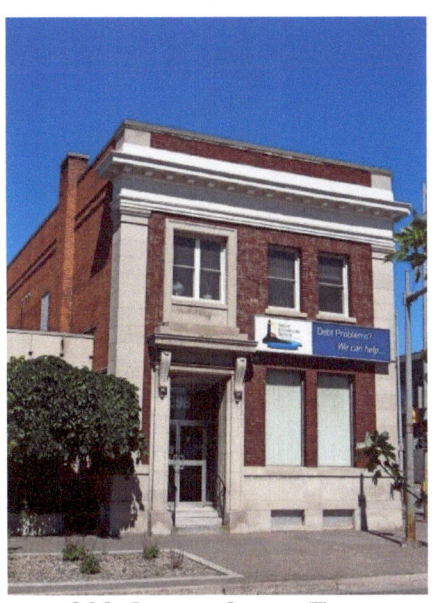

298 Queen Street East

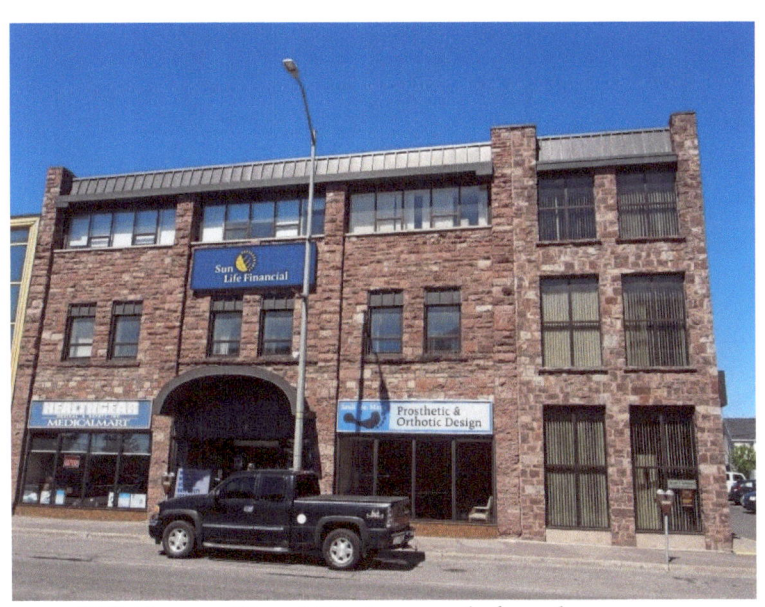

262 Queen Street East - rough faced masonry

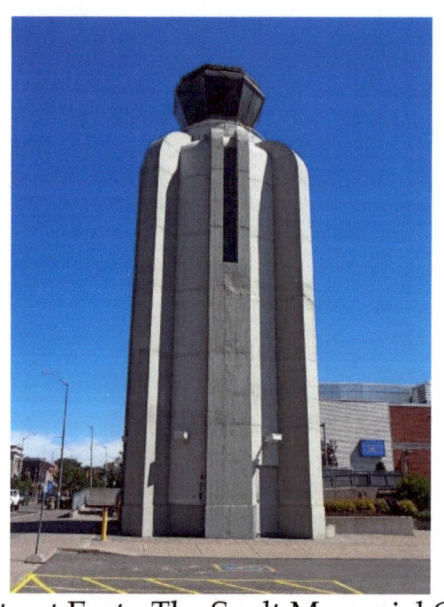

269 Queen Street East - The Sault Memorial Gardens was completed in 1949. It was in the Moderne style of architecture in its use of concrete, glass blocks and stainless steel and in its functional streamlined form. The Memorial Tower commemorates those who died in the World Wars and Korean War. A lamp cupola caps the tower. The Sault Memorial Gardens was demolished in 2007 to make way for a more modern structure, but the Memorial Tower was preserved. The Sault Memorial Gardens was the community's main entertainment venue and its hockey home for fifty years.

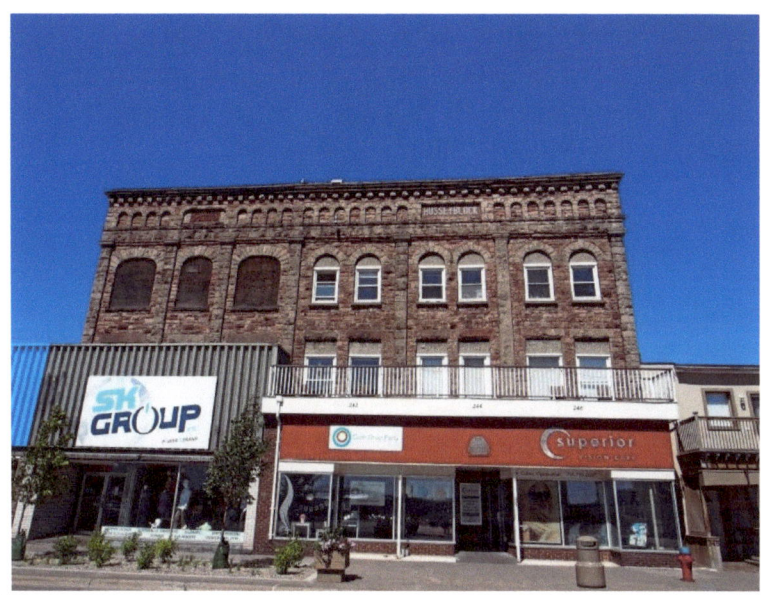

242-246 Queen Street East - The Hussey Block is an example of Romanesque Revival architecture using local materials. Developed by John A Hussey, who arrived in Sault Ste. Marie in 1890 and took a job working on the construction of the canal, the Hussey Block reflects the confidence he had in the economic growth of Sault Ste. Marie. Hussey established a butcher shop and later partnered with Thomas Drury to form the Hussey, Drury and Co. Wholesale and Retail Butchers. In addition to his active business involvement, Hussey was also active in the community, serving as a member and President of the Sault Ste. Marie Board of Trade, member of the Rotary Club, the Knights of Columbus, the Catholic Order of Foresters and the St. Vincent de Paul Society, and as an Alderman. The two wider flanking bays embrace, at sidewalk level, large and (for the time and location) very daring store windows. The narrower center bay contained doors to the two flanking stores, the two basement stores and the second floor.

The second floor was originally designed as a lodge hall for lease to the Catholic Order of Foresters. It has projecting pilasters, blind arcading and arched window and door openings of the front façade, a finely detailed parapet and dentilled cornice.

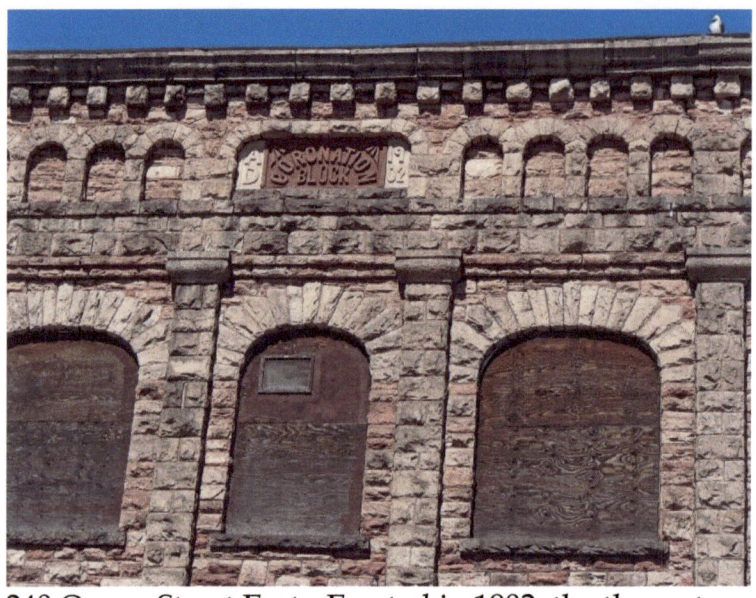

234-240 Queen Street East - Erected in 1902, the three storey red sandstone Coronation Block is flanked on the east by the Hussey Block. It is an example of Richardsonian Romanesque architecture using local materials with rough-dressed sandstone walls. The sandstone was excavated during the construction of the International Locks. The development of the Coronation Block and the Hussey Block made an important contribution to the commercial development of the Queen Street East commercial district. The Coronation Block was an important monument to its namesake, the recently crowned son of Queen Victoria, King Edward VII.

220-224 Queen Street East

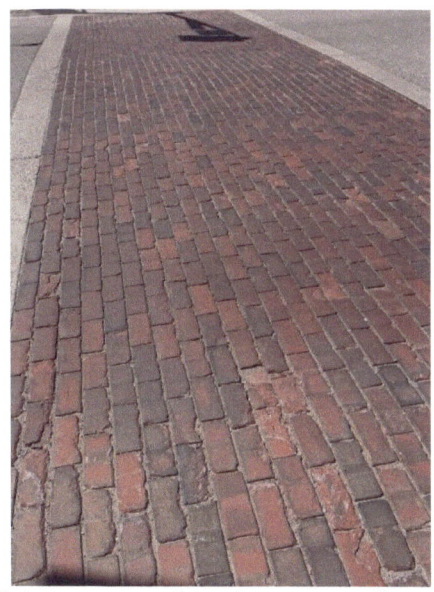

The paving brick incorporated in the crosswalks at Bruce & Queen and Bruce & Bay and on the eastern boulevard was obtained from the Metropolitan Paving Brick Company of Ohio. Until 1907, it formed the road surface on lower Bruce Street.

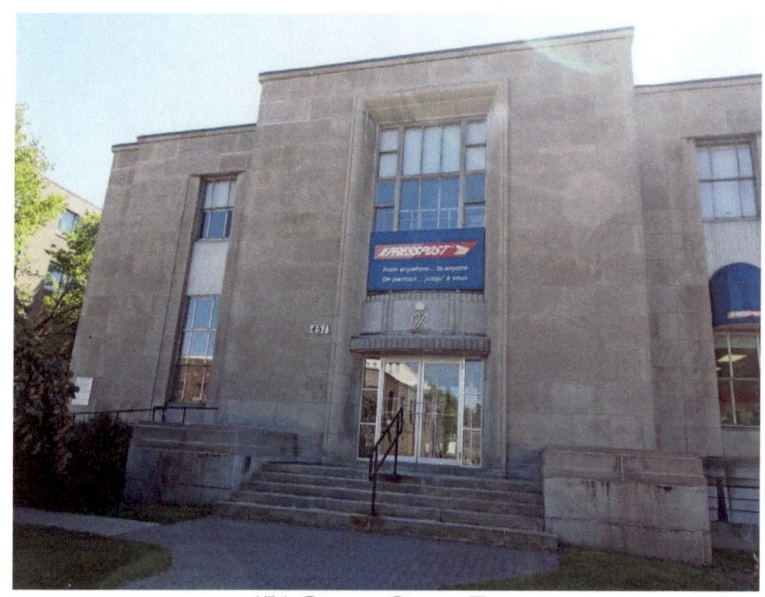
451 Queen Street East

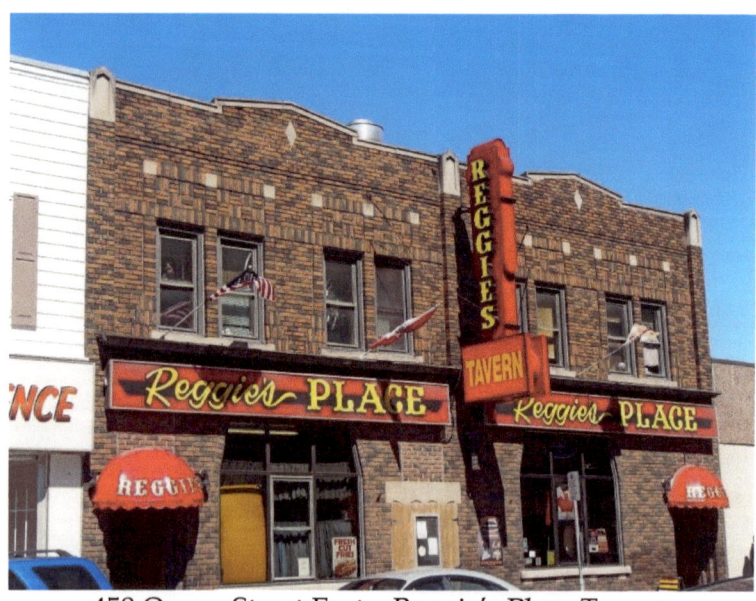
458 Queen Street East – Reggie's Place Tavern

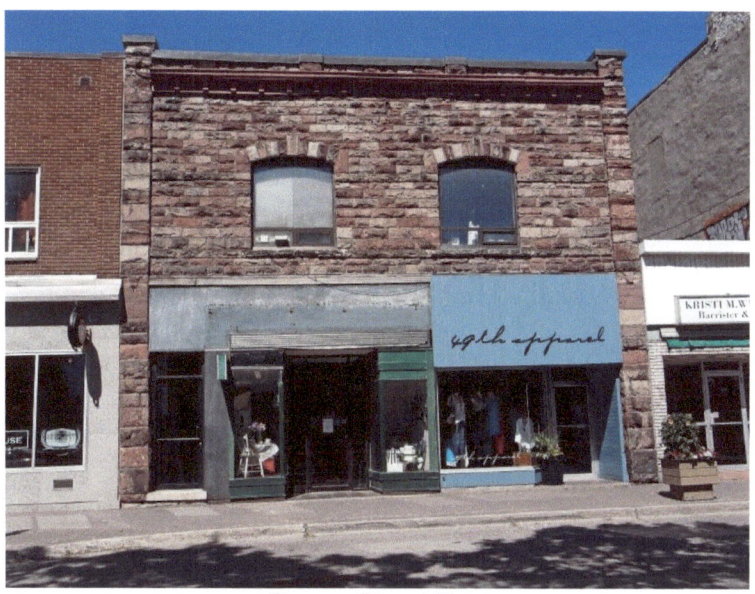
Queen Street East

486 Queen Street East

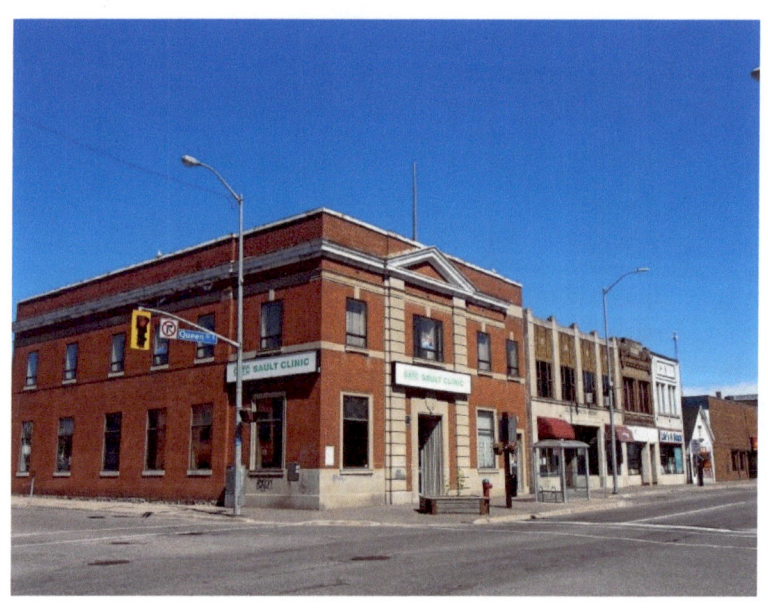

500 Queen Street East – QATC Sault Clinic

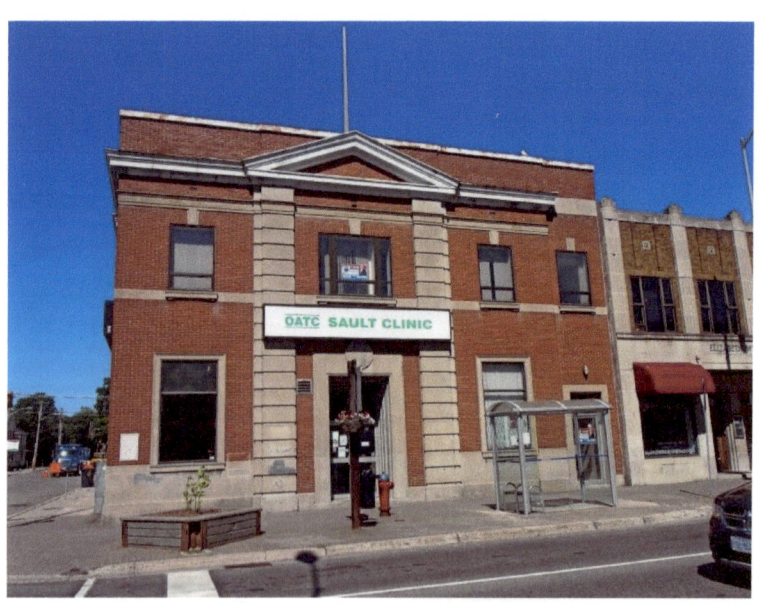

Pediment, banding, pilasters

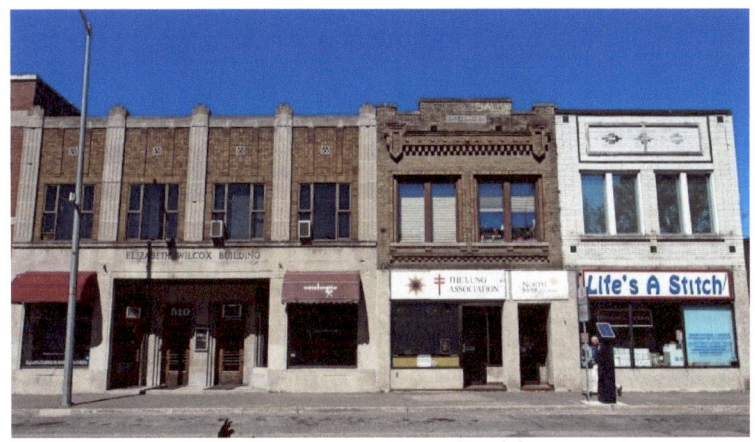

510 Queen Street East – Wilcox Building – pilasters

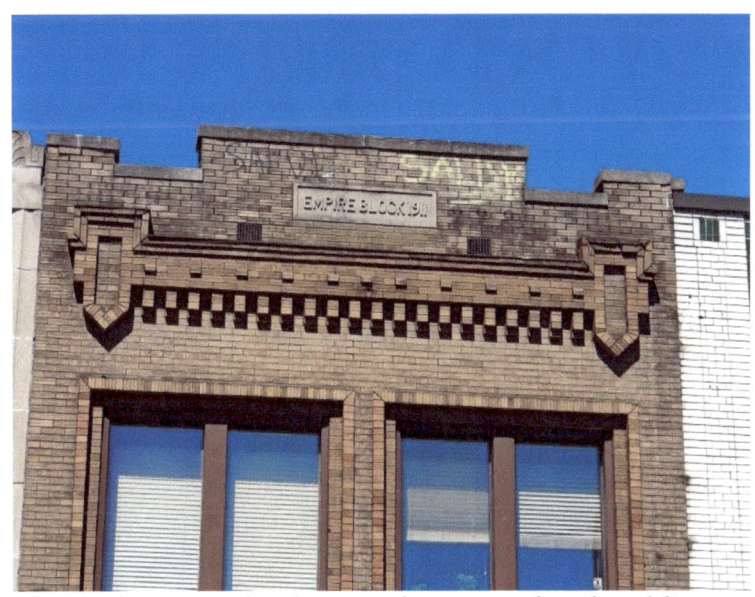

Empire Block – 1911 – battlemented parapet, dentil molding, raised decorative brick face

548 Queen Street East – voussoirs and keystones, blind transom windows

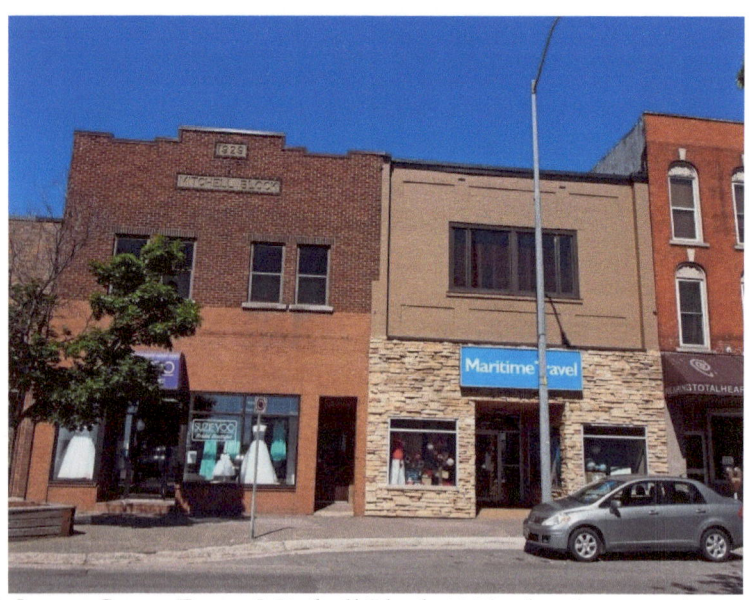

536 Queen Street East – Mitchell Block 1929 – battlemented parapet

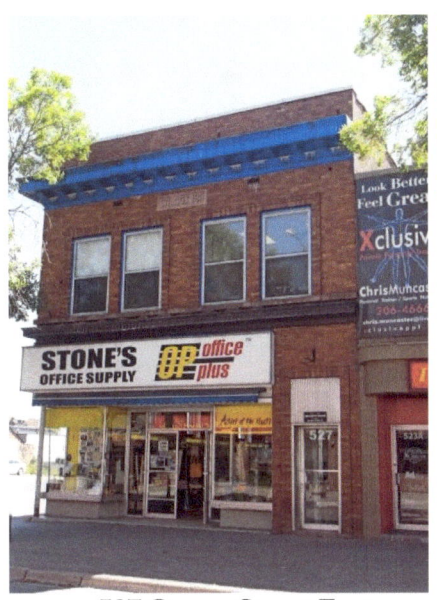

527 Queen Street East
Wilcox Building – 1911
Cornice brackets, dentil molding

736 Queen Street East
pilasters, cornice brackets

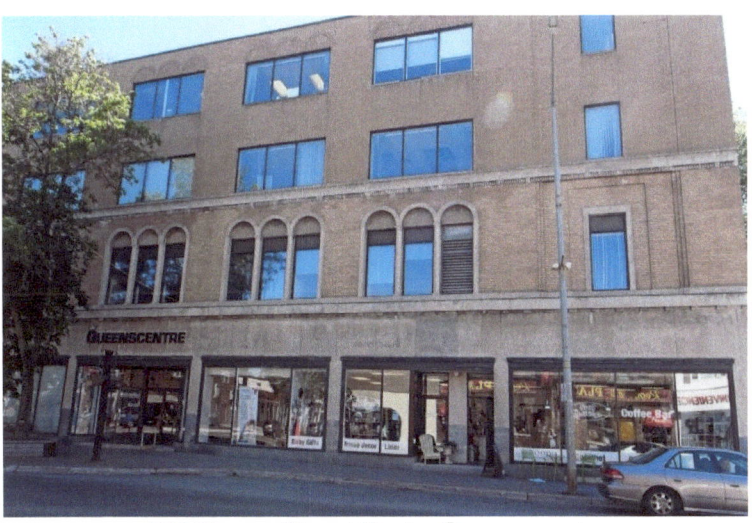

477 Queen Street East - Queenscentre

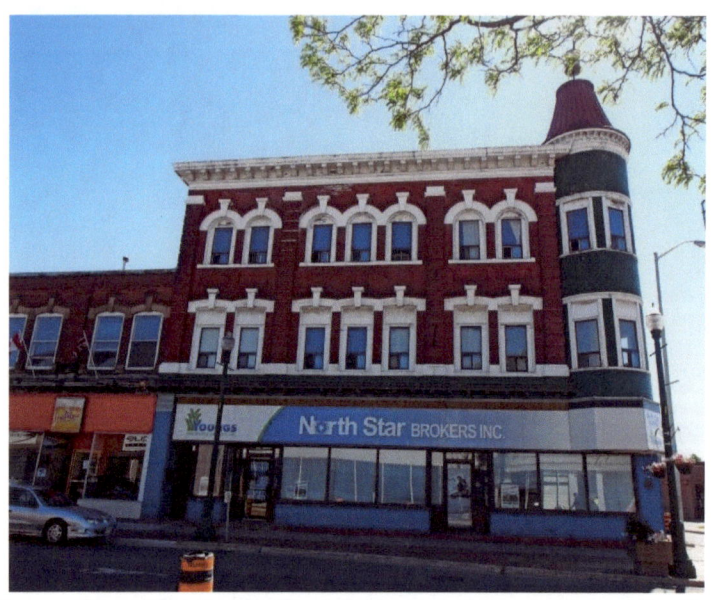

3-7 Queen Street East – Built at the turn of the century, the Barnes Block combines a Gothic corner turret with a late Victorian Italianate north façade. A mortar and pestle which rise from the truncated roof are a reminder that the building was originally built as a drug store.

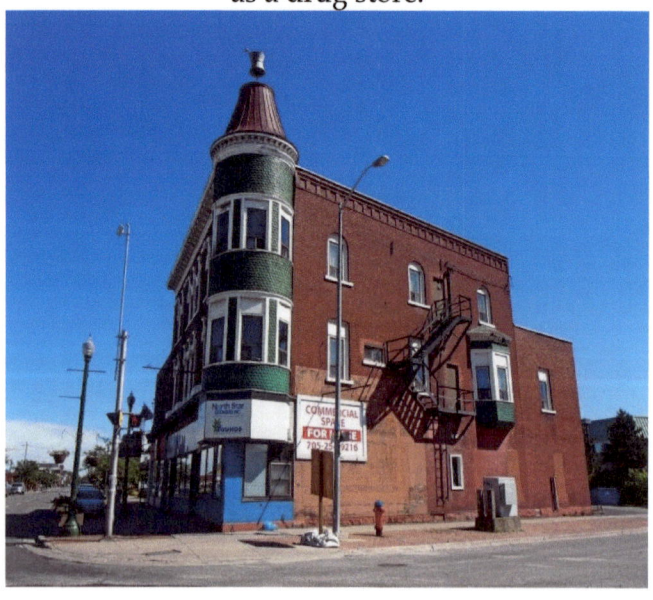

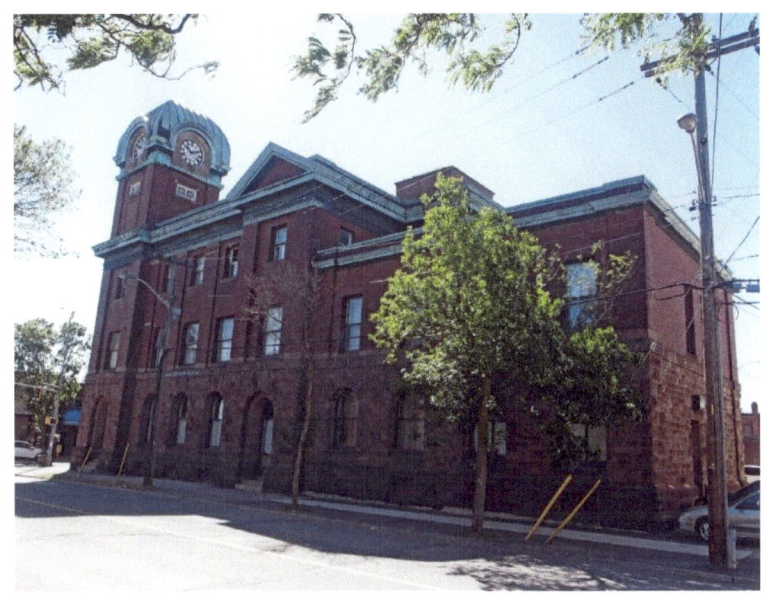

690 Queen Street East – Sault Ste. Marie Museum

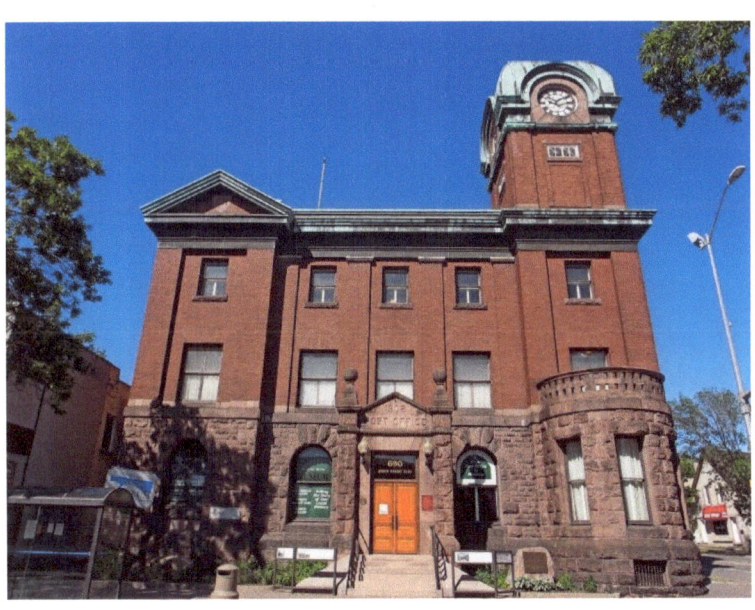

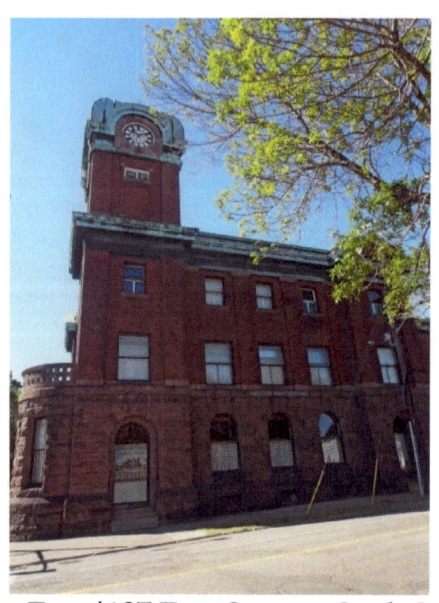

690 Queen Street East/107 East Street – Sault Ste. Marie Museum - The Old Post Office is an imposing three storey red brick and stone building featuring a clock tower. It is prominently located in downtown Sault Ste. Marie at the intersection of Queen Street East and East Street. Built between 1902 and 1906 as a federal building, it was purchased in 1982 by the City for use as the Sault Ste. Marie Museum. It is a fine example of turn of the century Federal architecture in Ontario, combining Victorian classicism with excellent workmanship. Exterior elements include classical pediments, pilasters and cornices, Romanesque stone arches with Italianate detailing and decorative features. Inside there is an oak staircase, an exquisite three-story light well and skylight, and a plated glass floor.

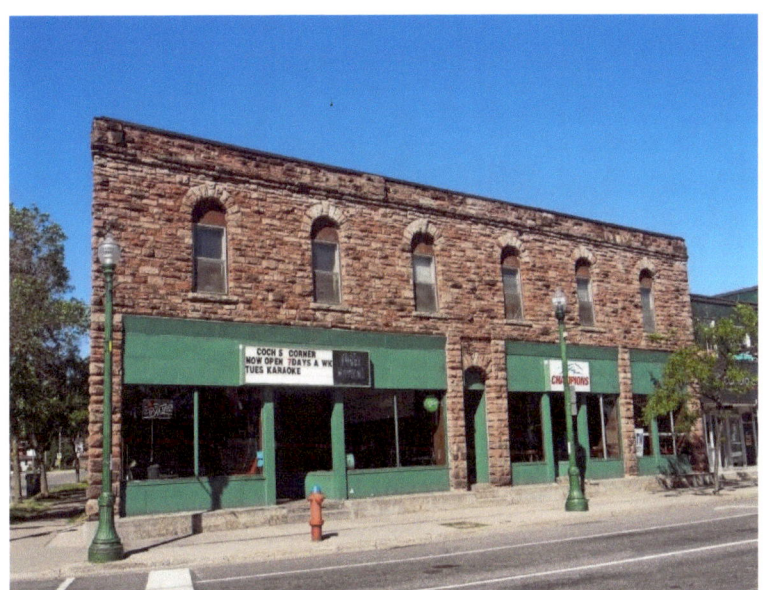

708 Queen Street East - The Dawson Block, built in 1894, is a two storey local red sandstone commercial building on the northeast corner of Queen and East Streets. Sharing this major intersection with the Old Post Office, it is located toward the eastern end of the Queen Street East commercial district. John Dawson, the patriarch of a family with a long and significant record in commerce, public service and politics in Sault Ste. Marie built the Dawson Block in 1894 to house the family grocery business on the main level. Subsequently the Dawson Block has housed a number of community organizations including the Odd Fellows and former owners, the International Order of Foresters and the Knights of Columbus. Although it is still a solid, attractive building, it has been much altered over the years, particularly with the removal of the Mansard roof and later with the removal of the whole third floor after a fire in 1953. There is a Knights of Columbus crest on the east façade. There are six arched second storey windows on the front façade.

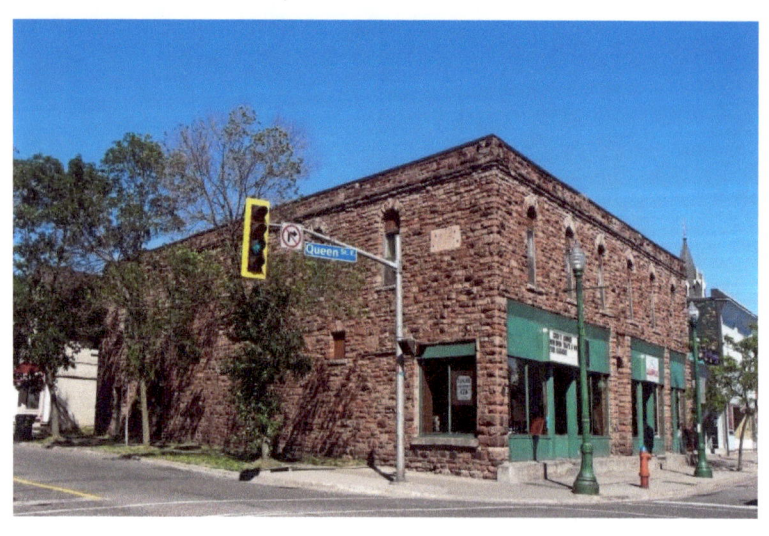

CTV

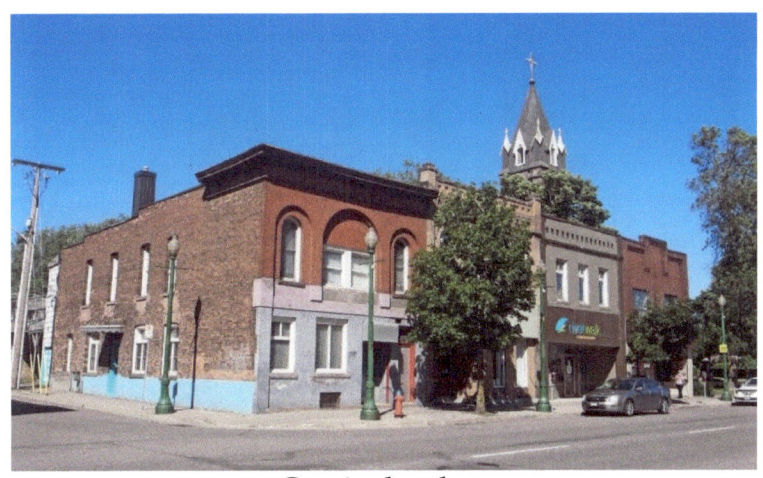

Cornice brackets

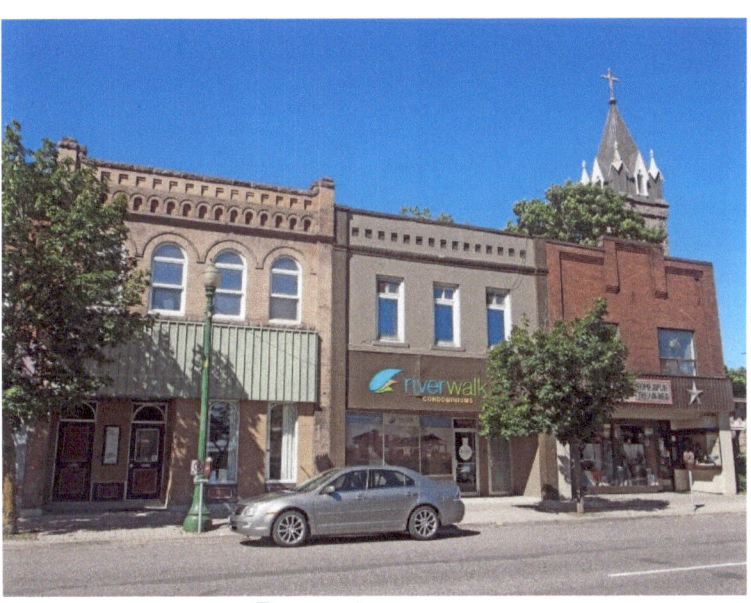

Decorative parapet

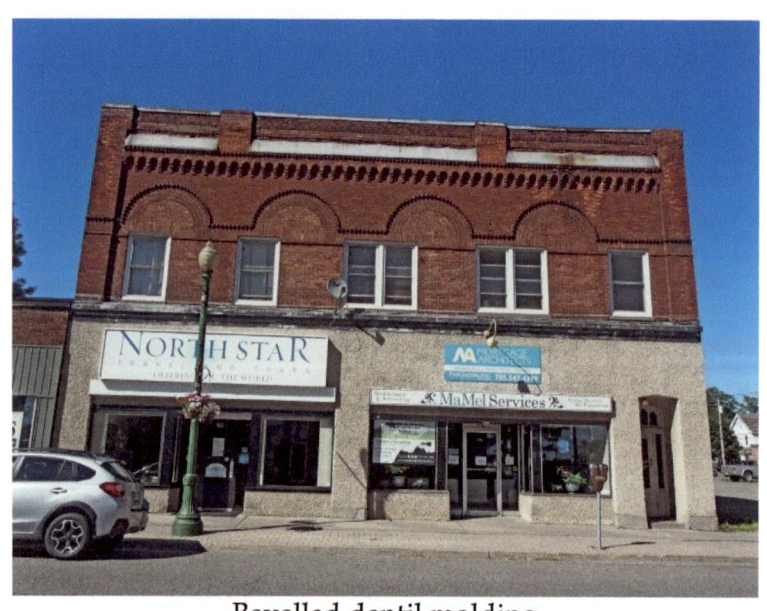

Bevelled dentil molding
794 Queen Street East – formerly Swifts Premium Meat

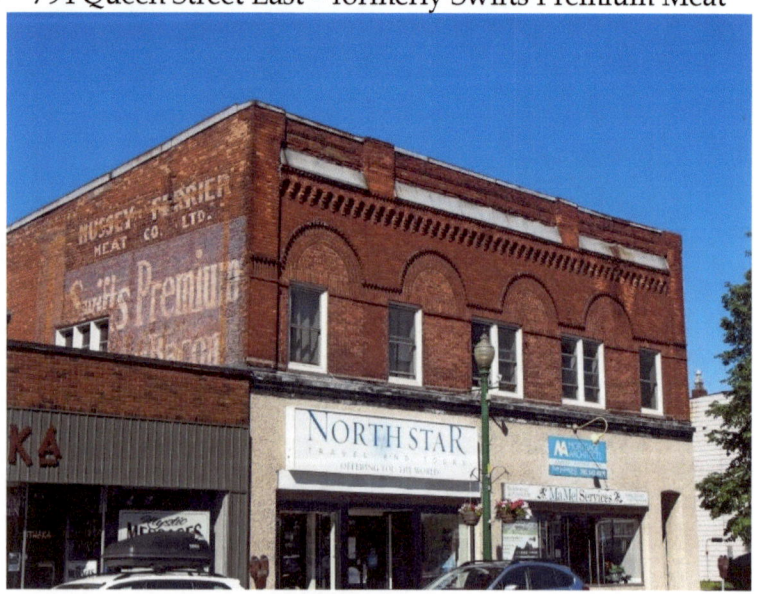

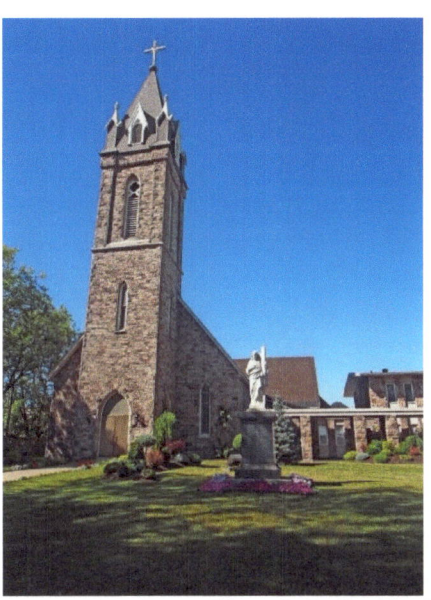

778 Queen Street East – Precious Blood Cathedral is set back from the main streetscape in a park like setting. This simple Gothic church, constructed in 1875-1876 of local red and grey sandstone, is made more visible by a bell tower and spire. It is the oldest surviving church in Sault Ste. Marie. It was originally known as Sacred Heart Roman Catholic Church, receiving its current name in 1936. It served as a parish church before becoming the cathedral for the newly-created Diocese of Sault Ste. Marie in 1904. The Cathedral is a reminder of the long history of the Roman Catholic Church in Sault Ste. Marie which began when Jesuit priests celebrated the first mass in the Sault in 1641. A simple, wood Roman Catholic missionary church is known to have existed close to the site of the present cathedral as early as 1846.

The transepts set crosswise to the nave in a cruciform (cross-shape) were added in 1901, as were stained glass windows. The 1925 marble statue in front of the church commemorates the martyrs who died in establishing the church in the area. There is a single nave, a gable roof clad in slate, and a stone bell tower, belfry and four-sided spire clad in metal shingles. Alternating sizes of stone surrounds and arrow-shaped keystones decorate the lancet windows and Gothic doors.

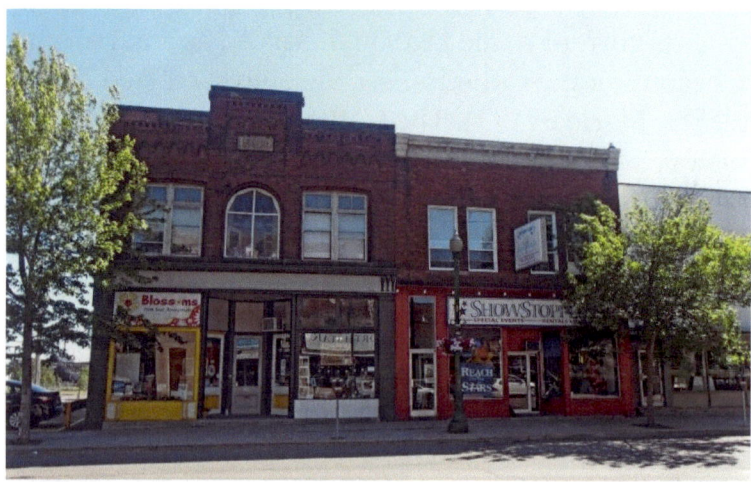

805 Queen Street East – 1904 – bevelled dentil molding

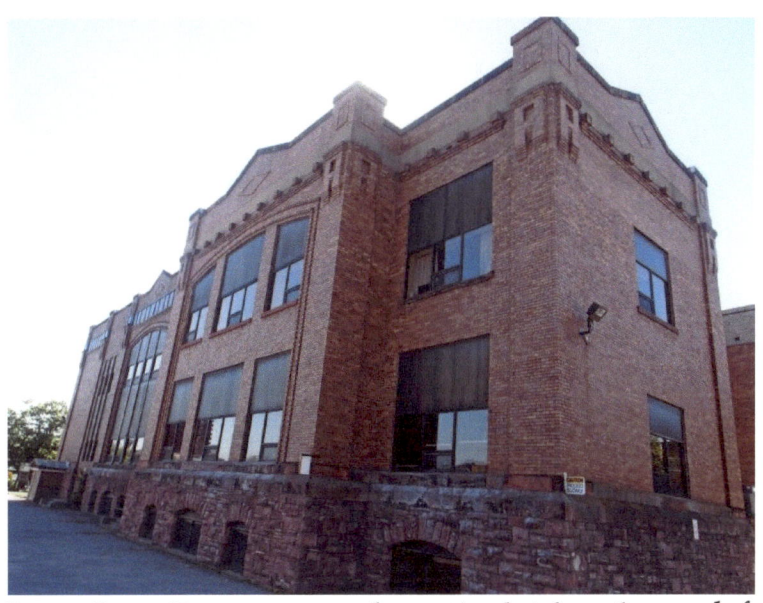

819 Queen Street East – parapet, decorative brickwork, rough faced masonry foundation

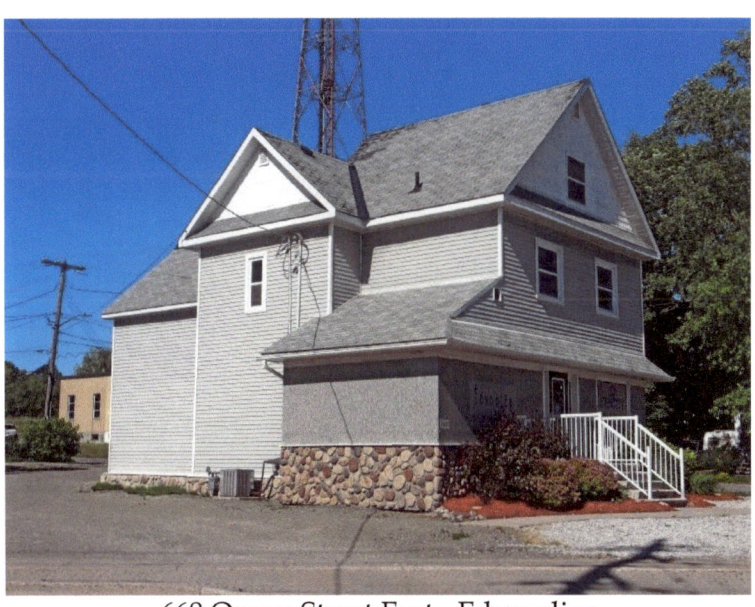

668 Queen Street East - Edwardian

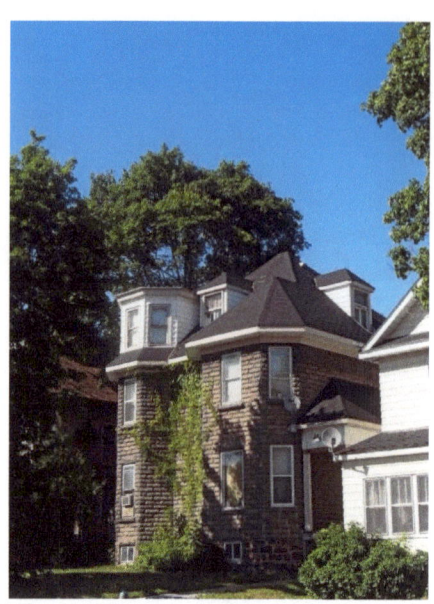

650 Queen Street East – Queen Anne style – three-storey tower-like bay, dormers

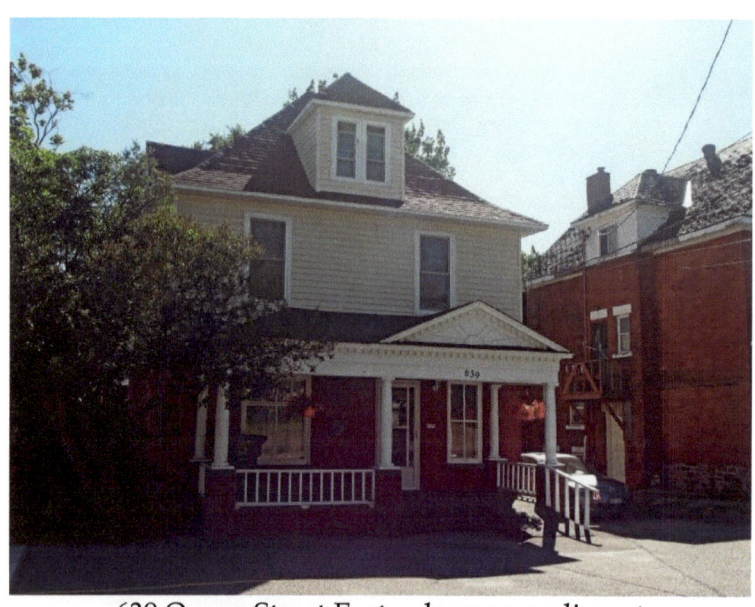

639 Queen Street East – dormer, pediment

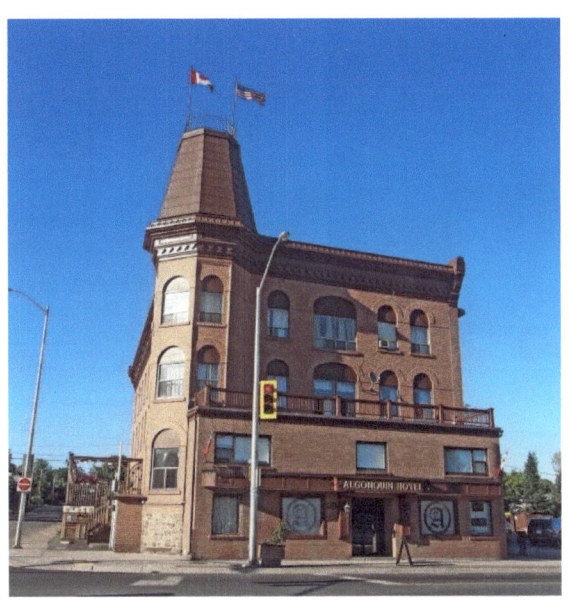

864 Queen Street East – Built in 1888, the Algonquin Hotel is a four-storey brick structure located in close proximity to the north shore of the St. Marys River on the northwest corner of Queen Street East and Pim Street. The Algonquin is the sole survivor of the large hotels built close to the turn of the twentieth century to cater to a rapidly expanding industrial center. These hotels were clustered around Sault Ste. Marie's docks to serve arriving settlers and workers. The hotel is a good example of Victorian commercial architecture. Key elements that reflect the architectural style are the use of brick masonry, including the masonry arches over the windows, the truncated tent roof which caps the southwest polygonal corner of the hotel, the painted metal cornice on the Queen Street and Pim Street facades, and the chevron molding on the Queen Street and Pim Street cornices.

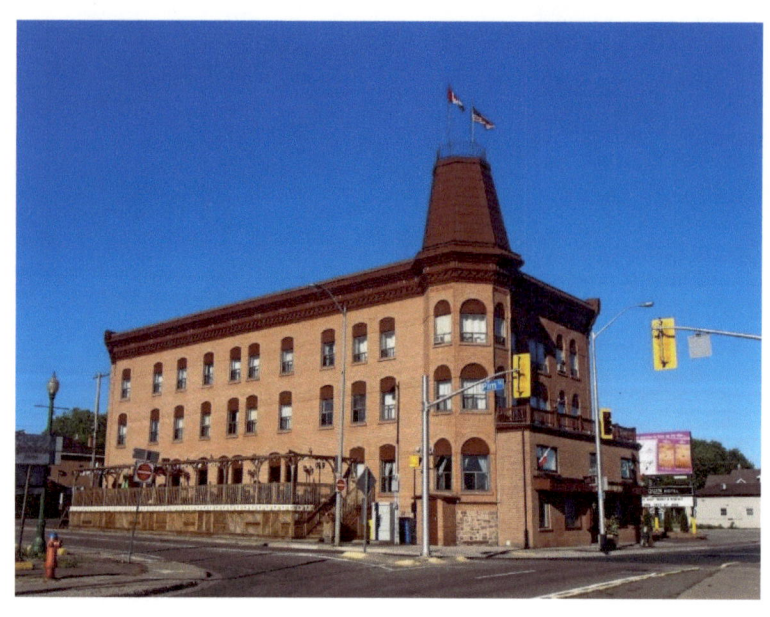

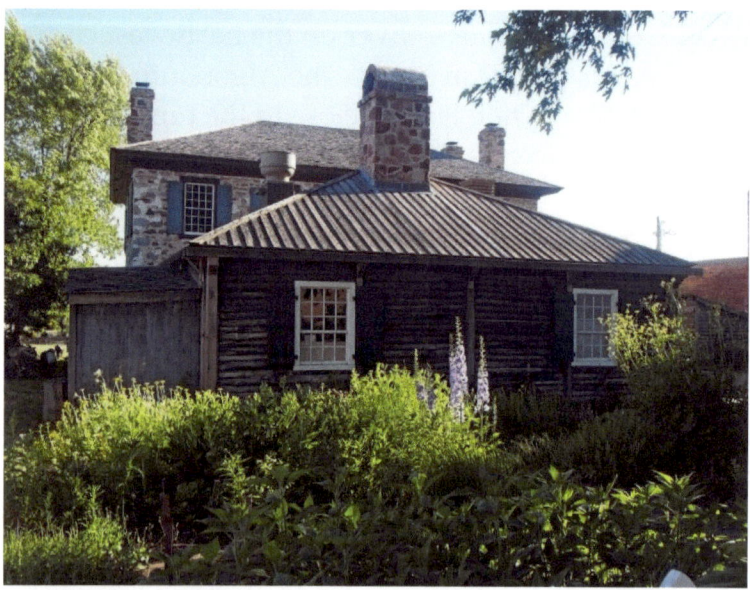

The Ermatinger Old Stone House - cobblestone

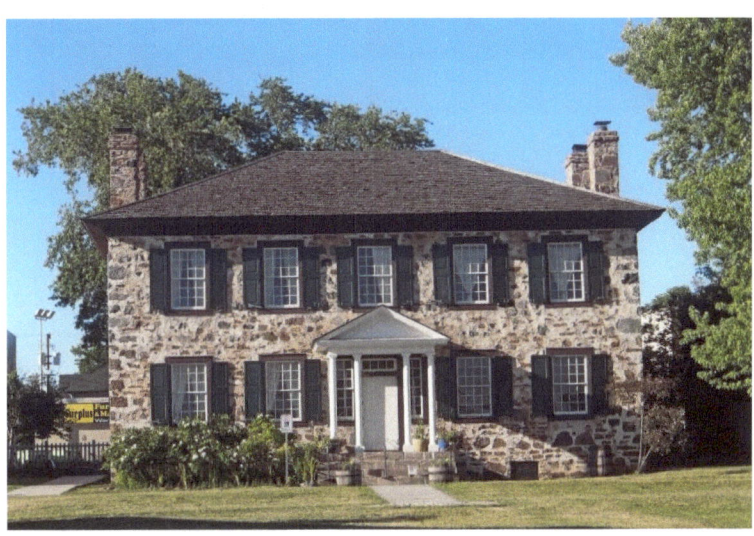

831 Queen Street East - The Ermatinger Old Stone House is a two-storey stone structure built on the north bank of the St. Mary's River near the rapids in Sault Ste. Marie. The house provides a link to Sault Ste. Marie's role in the fur trade and to one of its earliest settlers. Charles Oakes Ermatinger, a member of a prominent Montreal family who joined the Northwest Company and married Charlotte Katawabeda, the daughter of the Paramount Chief of the Ojibway, built the house in 1812-1814 of local red sandstone in a style characteristic of vernacular Georgian architecture but employed Quebec construction techniques. The house quickly became the center of government in the northwest part of the province and of the business and social life of the district. It later served as the first courthouse, a post office and a hotel. The house served as the headquarters of Sir Garnet Wolseley in 1870 when the expedition he commanded stopped at Sault Ste. Marie enroute to quell the Red River Rebellion and to establish Canadian sovereignty over Manitoba and the Northwest Territories.

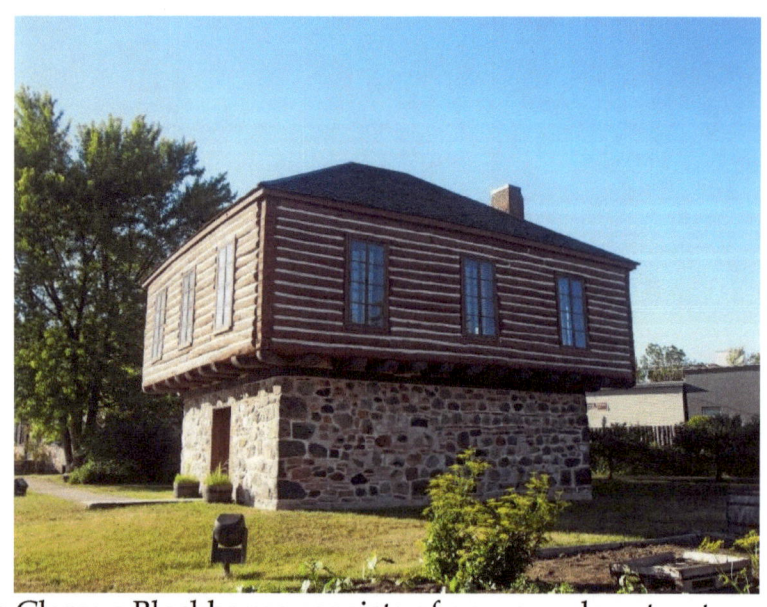

The Clergue Blockhouse consists of an upper log structure on an uncut fieldstone base. Originally located on the St. Mary's Paper site, adjacent to the Canadian Canal, the Blockhouse is now located to the east of the Ermatinger Old Stone House at the corner of Bay and Pim Streets in downtown Sault Ste. Marie. The stone walls of the Clergue Blockhouse were constructed in 1819 of uncut fieldstone and are the only remains of the North West Company Post in Sault Ste. Marie.

Stark and simple in its design, this former powder magazine is an example of unadorned, wilderness architecture used by early fur trading companies. The upper log structure, designed as a blockhouse in the style of those constructed during the Indian Wars of the preceding one hundred years, was added in 1894 by the American entrepreneur Francis H. Clergue for use as his residence and early office. The original location of this 'bachelor apartment' at the St. Mary's Paper plant allowed Clergue to survey early industries under his control including a hydro-electric plant, a pulp and paper mill, a steel plant, and a rail and marine transportation network at the industrial site located at the confluence of Lake Superior and Lake Huron, adjacent to the Canadian Canal.

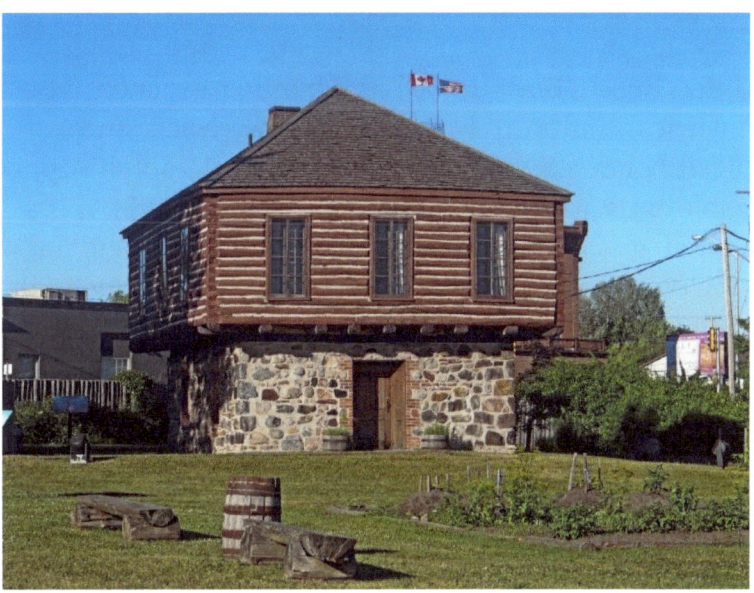

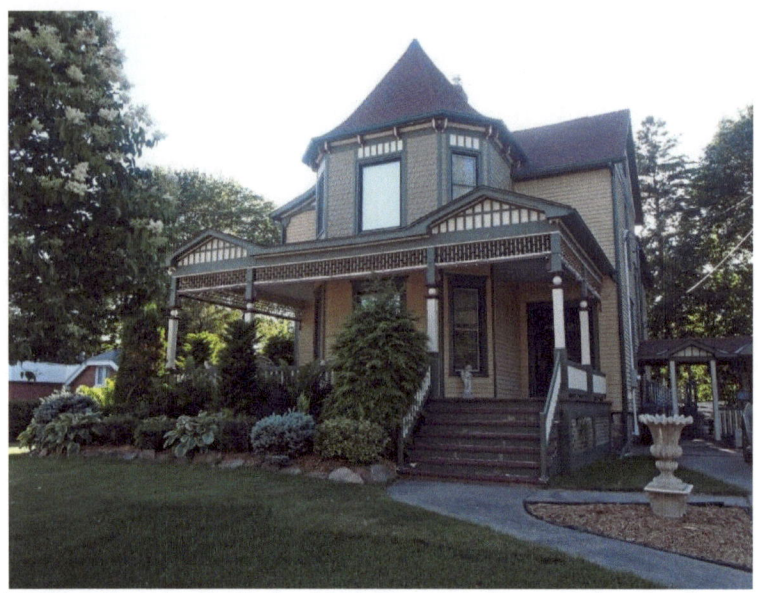

115 Upton Road - Built in 1902 as a family residence, the asymmetrical composition, turret and the variety and complexity of detail seen in the spindle work, porch supports and gable ends are typical of the Queen Anne style. It is a substantial, gracious and elegant framed dwelling on the west side of Upton Road in the east end of the older residential core. Edward L. Stewart, Manager of the International Lumber Company was the original owner and hired Thomas McKissock to begin construction in 1902. The plan is cruciform shaped with the head forming the main east elevation. The main facade and the wraparound veranda are the most prominent features of the house. The classical style veranda was originally accessed by two sets of identical steps at each end emphasized by a classical pediment. There are cornice brackets on the hexagonal turret below the cone-shaped roof.

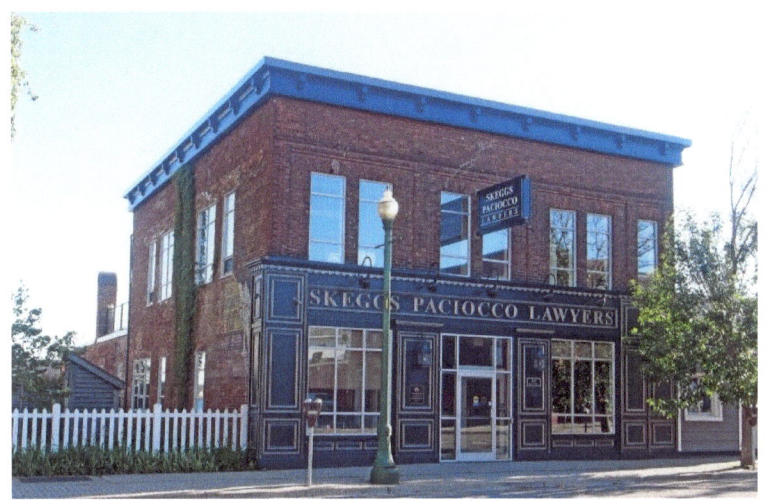

819 Queen Street East – cornice brackets

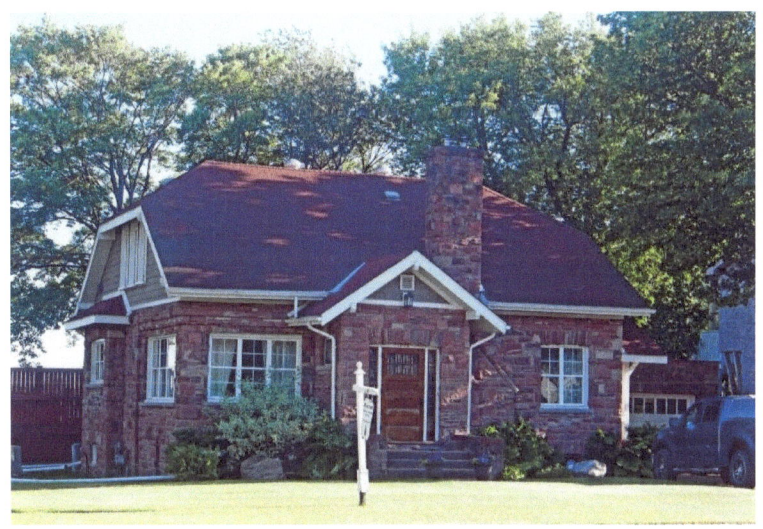

1035 Queen Street East

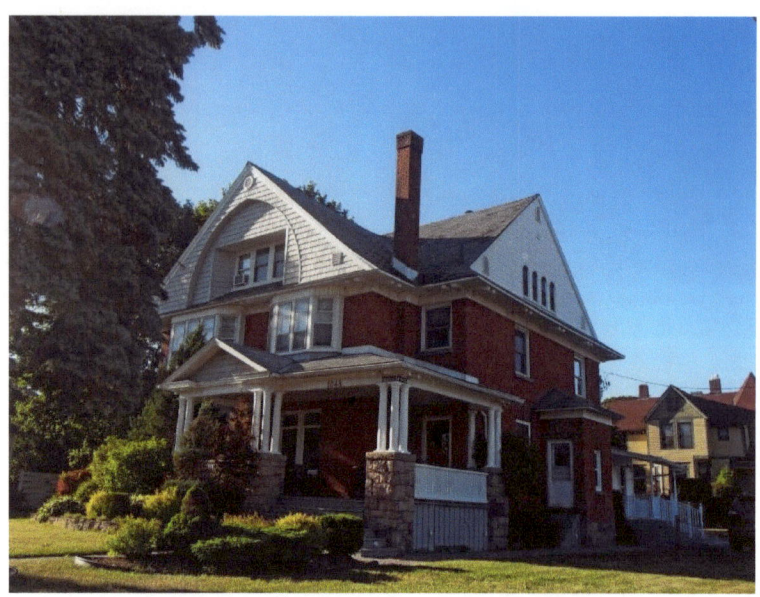

1048 Queen Street East - This residence is situated on a large treed lot at the south west corner of Queen Street East and Upton Road in the east end of the central residential core. William Howard Hearst established a legal practice in Sault Ste. Marie in 1888 and in 1904 built "Eastbourne" as his residence, naming it for its location in the east end of town. In 1908 Hearst became the Member of Provincial Parliament for Algoma and in 1914 the first Premier of Ontario from Northern Ontario. Eastbourne is a good example of Edwardian architecture using local materials. It was constructed in 1904 with a 't-shaped' plan; each of the arms are the same width and projection. Two-storeys in height with a full basement and attic, it is constructed of soft red brick and local red sandstone. It has a gabled roof and the attic gables are clad with painted wood shingles. The deep cornice and soffits have decorative brackets. Large bow windows dominate the east and west facades. The sash windows are triple and double hung. The porch has a broken pediment, pilasters and triple clusters of truncated Doric columns. The basement and porch foundations are of local red sandstone.

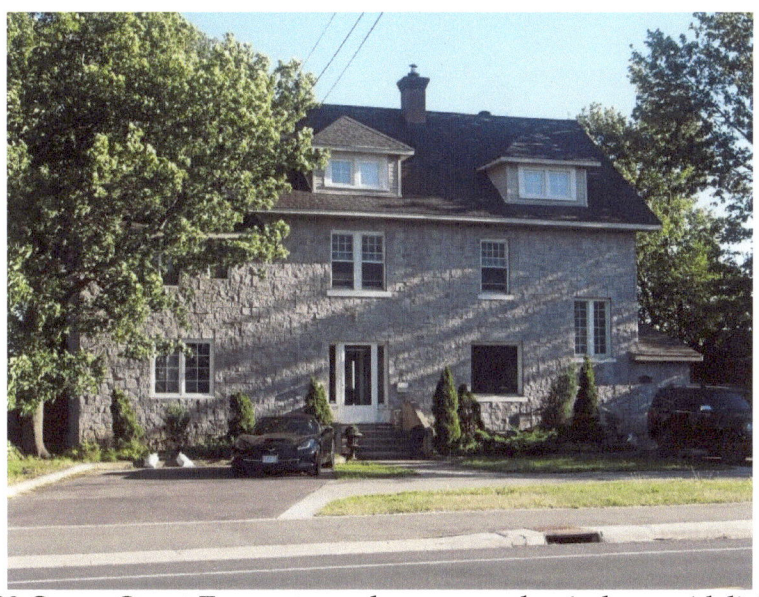

1033 Queen Street East – stone, dormers, sash windows, sidelights

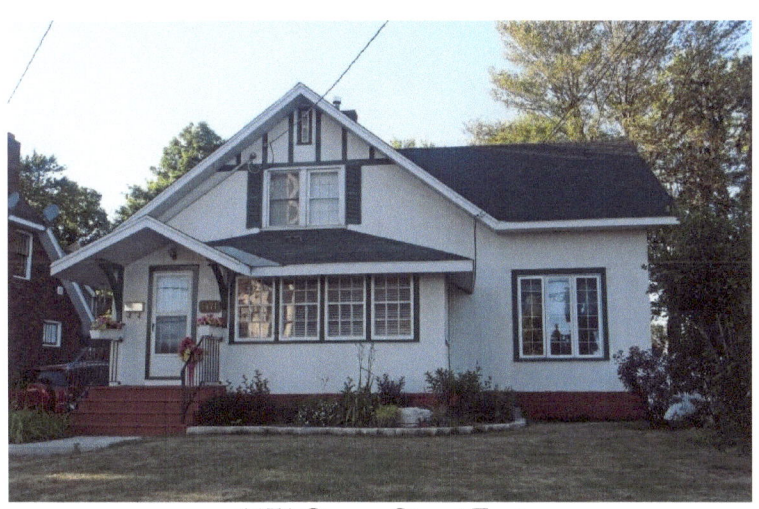

1174 Queen Street East

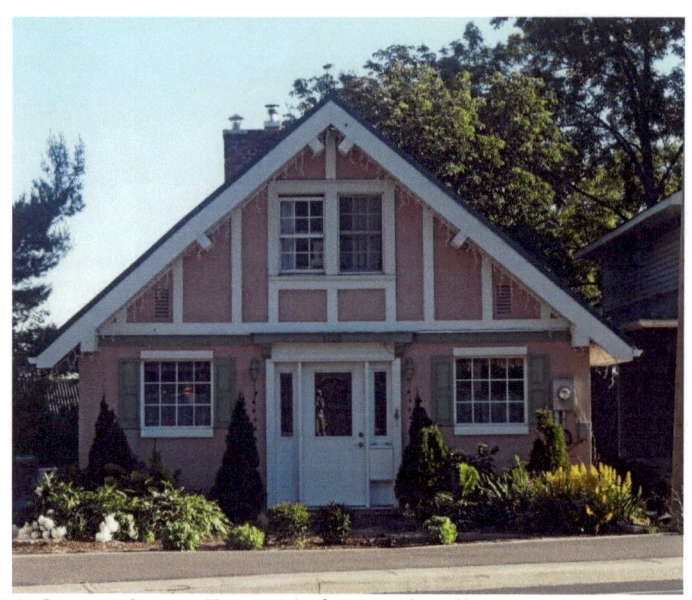

1129 Queen Street East – A-frame dwelling with Tudor half-timbering on the gable

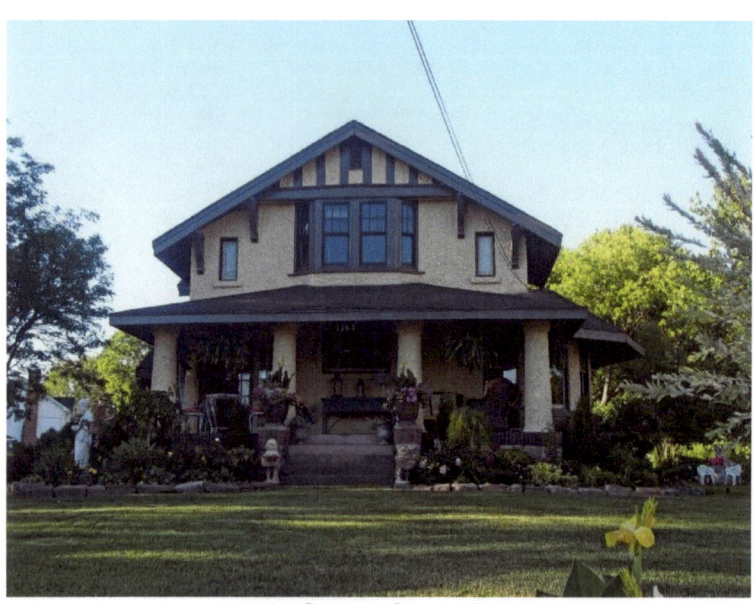

1164 Queen Street East

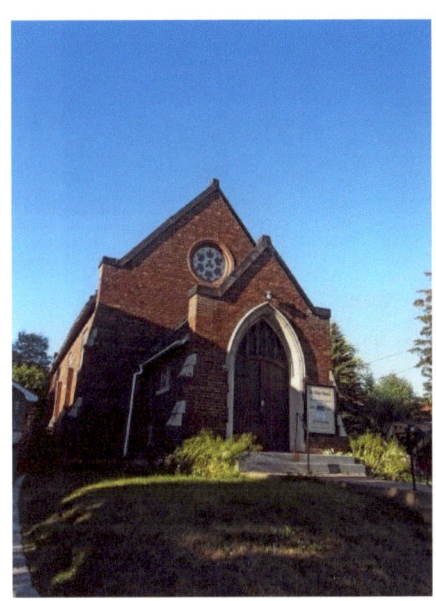 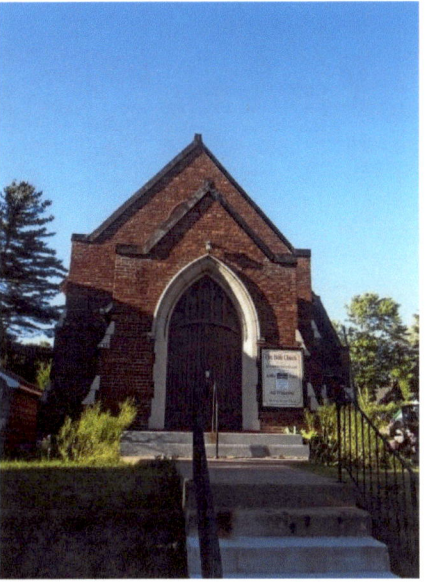

1100 Queen Street East – City Bible Church – Gothic style, rose window

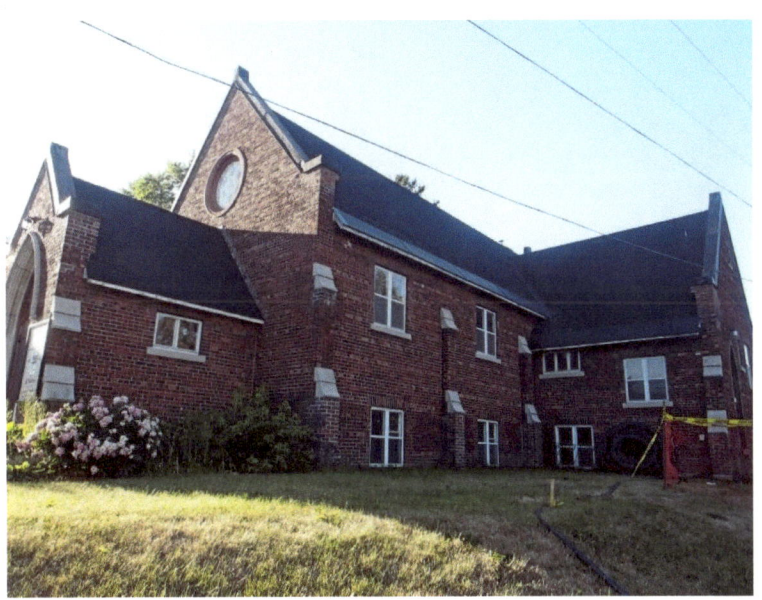

Buttresses

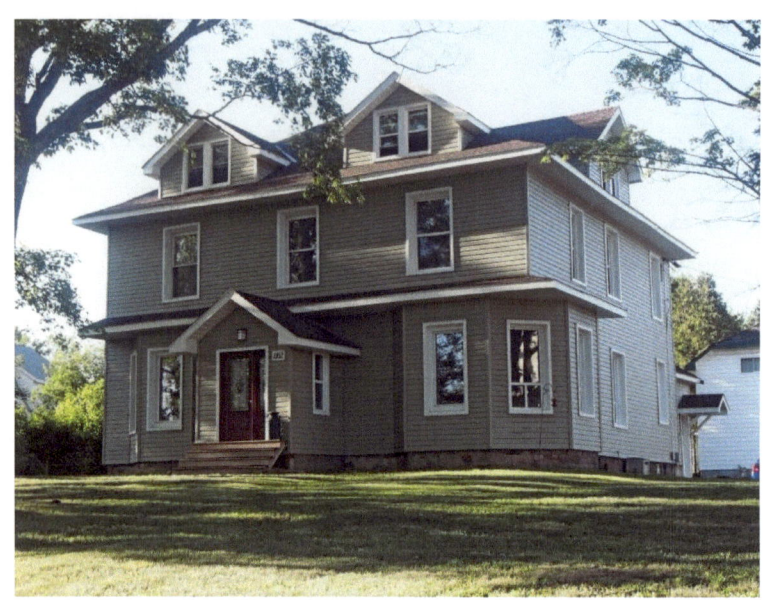

1162 Queen Street East - dormers

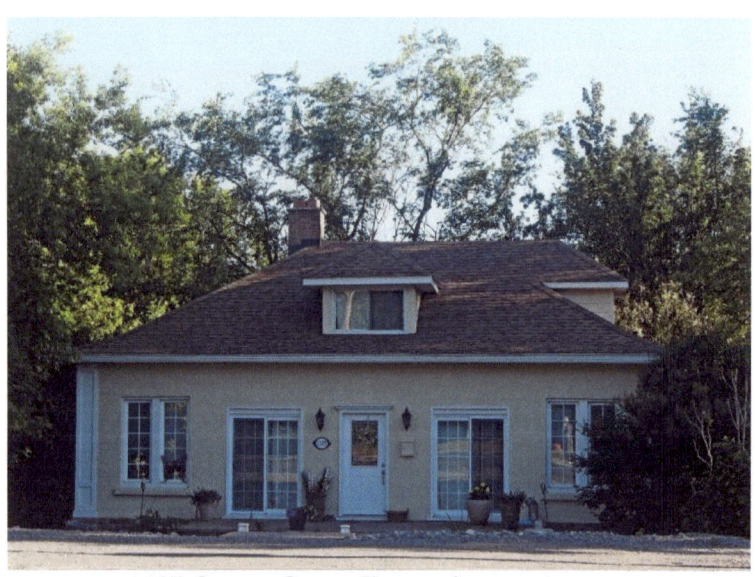

1105 Queen Street East – dormer in attic

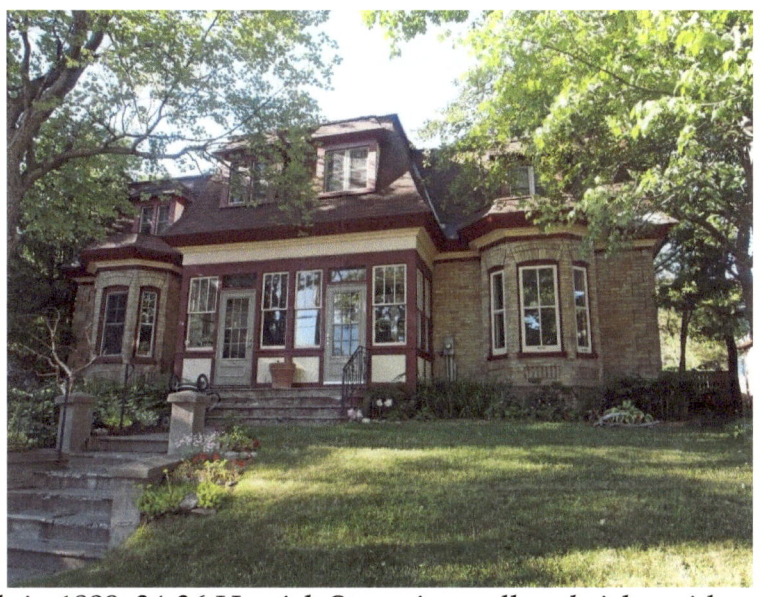

Built in 1889, 34-36 Herrick Street is a yellow brick residence located on a quiet dead end street in the east end of the older residential core of Sault Ste. Marie. This house is an early example of Second Empire style architecture. The south elevation of the main house faces the street and was built in a symmetrical fashion. It is heightened by a projecting central frontispiece that continues up into a mansard roof which was originally sheathed with cedar shingles. Around the turn of the century, a demising wall was constructed through the middle of the house and the front porch was rebuilt to accommodate separate front entrances for two semi-detached units.

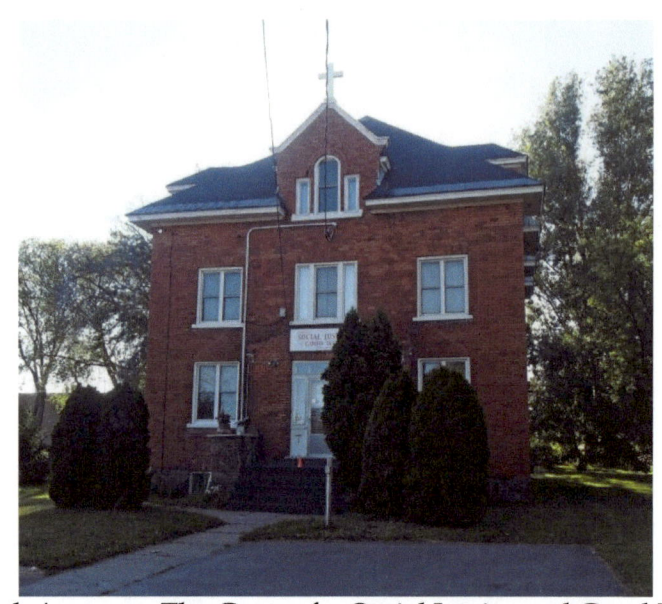

1 Herrick Avenue – The Centre for Social Justice and Good Works – Palladian type of window in the dormer

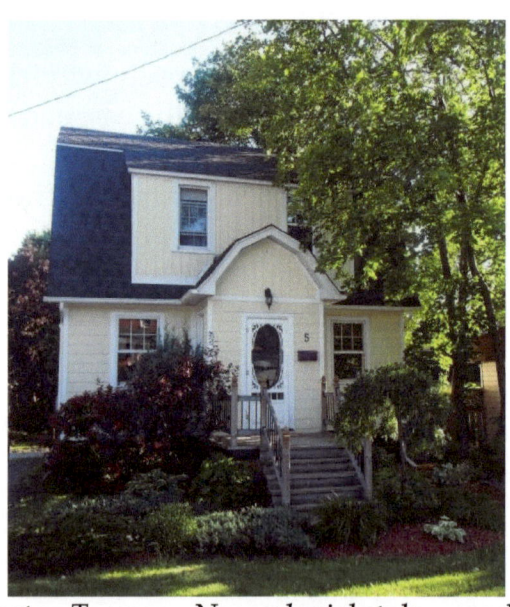

5 Kensington Terrace – Neo-colonial style – gambrel roof

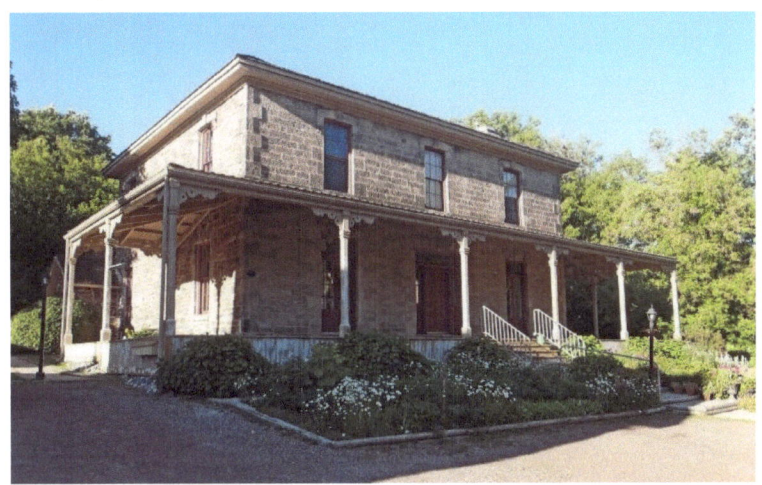

10 Kensington Terrace - Constructed circa 1865, Upton is a coursed gray ashlar two-storey residence located in the east end of the central residential core of Sault Ste. Marie. It visually provides a well-proportioned, dignified elevation to a quiet dead end street. It was built as the home of Wemyss Mackenzie Simpson. Simpson had come to Canada in 1840, serving with the Hudson's Bay Company in various capacities, including that of chief factor of the Sault post from 1862 until its closure in 1865. Following the closure of the post, Simpson was elected as the first Member of Parliament for Algoma. He served in that capacity from 1867 to 1872, at which time he resigned to accept the post of Indian Commissioner. Upton displays a Georgian style of architecture with Regency influences. The main house has a box-like structure and a low-hipped roof with smaller projecting wings. It has stone lintels, keystones and quoins, six over six sash windows, French doors, and a Regency style wood verandah.

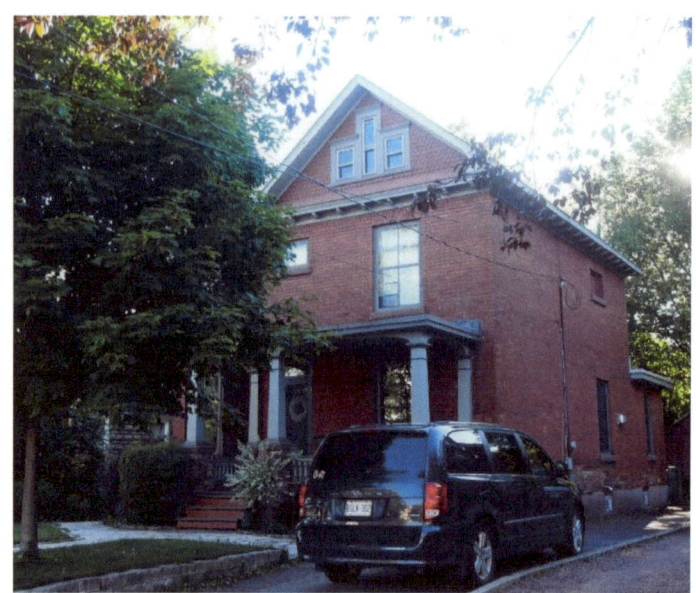

MacGregor Avenue – Edwardian style – Palladian window in gable, cornice brackets

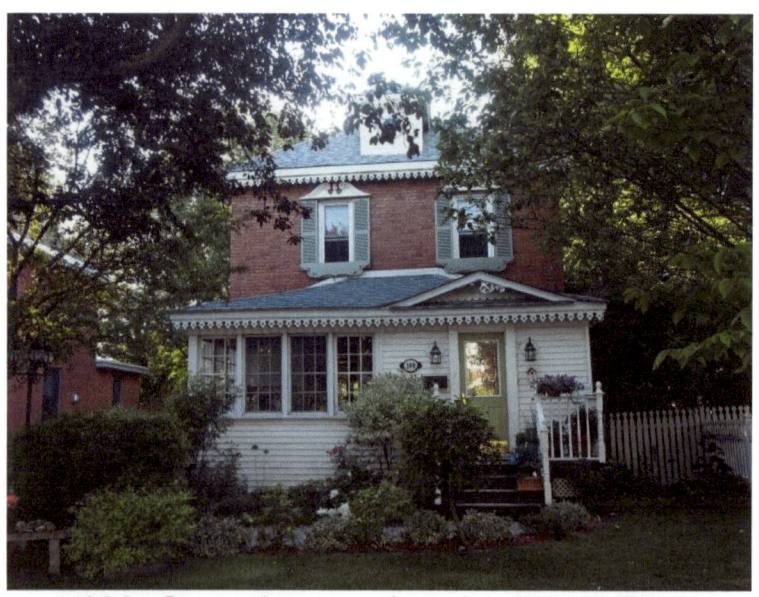

149 MacGregor Avenue – dormer in attic, pediment

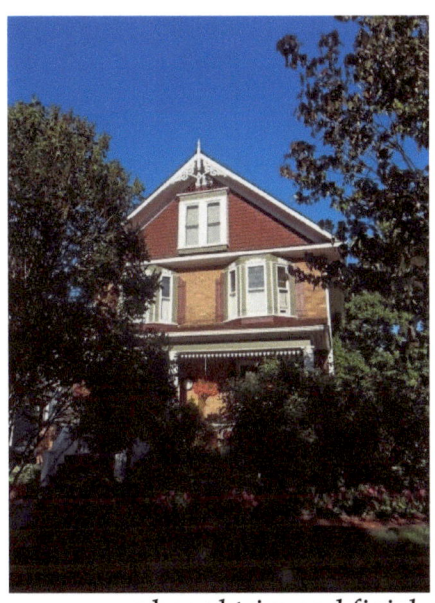

MacGregor Avenue – verge board trim and finial on gable, second-floor bay windows

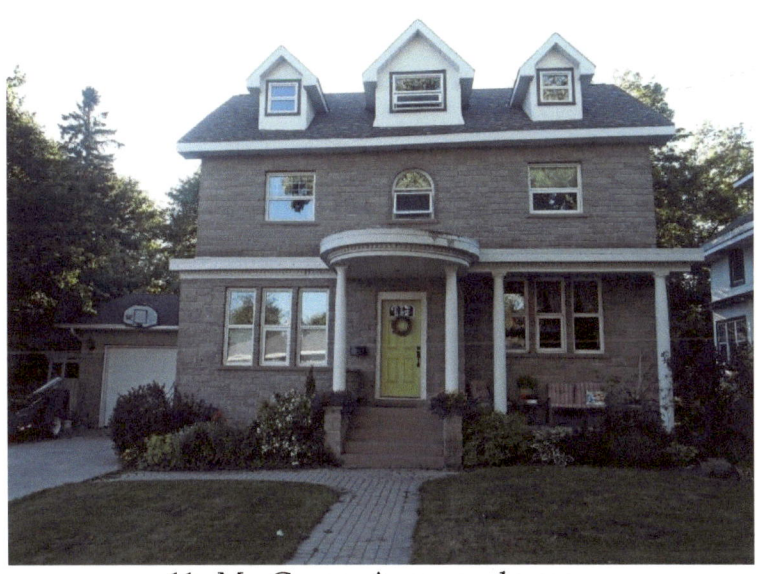

11_ MacGregor Avenue - dormers

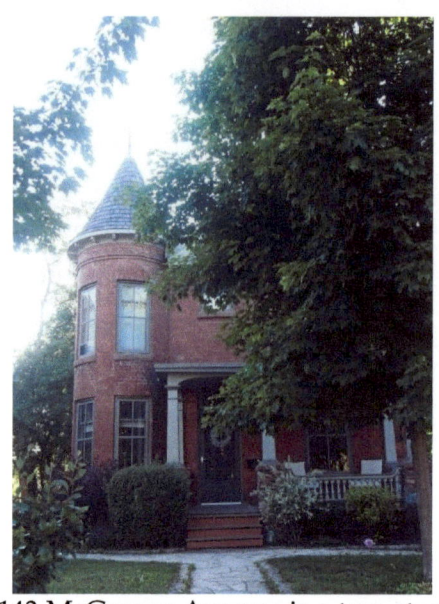

Built circa 1906, 143 McGregor Avenue is a two storey local red clay brick residence. It is also known as the McLeod Family Residence. Key character defining elements that reflect the heritage values include its wood windows and storm sashes in two over two pattern and leaded lights in the upper quarters, fish scale pattern in the gables, a circular two storey turret with conical cedar shingle roof capped with a pinnacle. It has a large entrance porch set on sandstone piers across the front of the house. It is built on a local sandstone foundation.

129 Bay Street – Algoma Central Railway

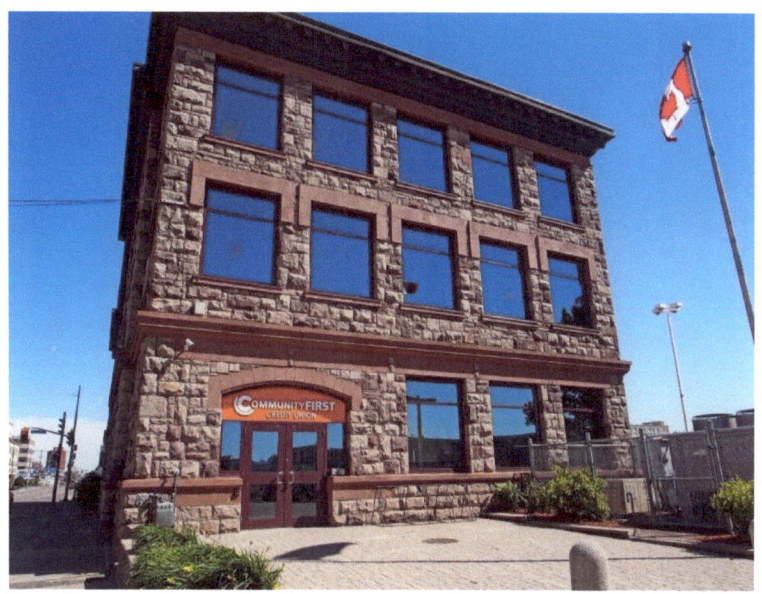

289 Bay Street – It was built in 1912 as the terminal station and head office of the Algoma Central and Hudson's Bay Company Railway Company. The A.C.R. was founded in 1899 by Francis Hector Clergue.

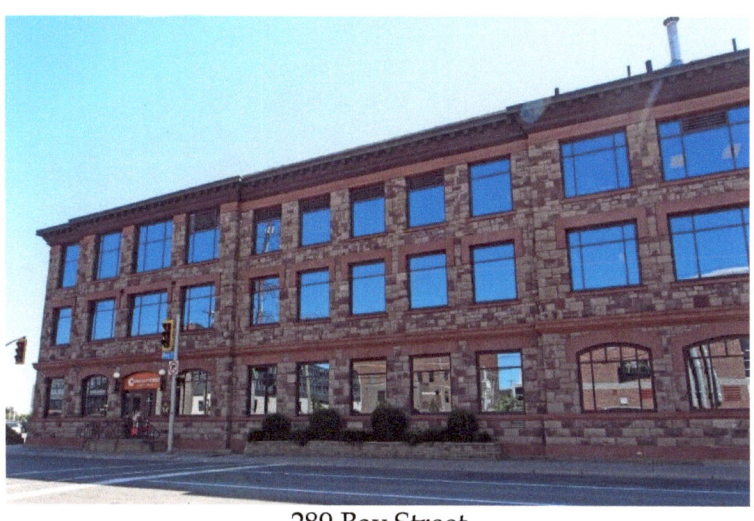

289 Bay Street

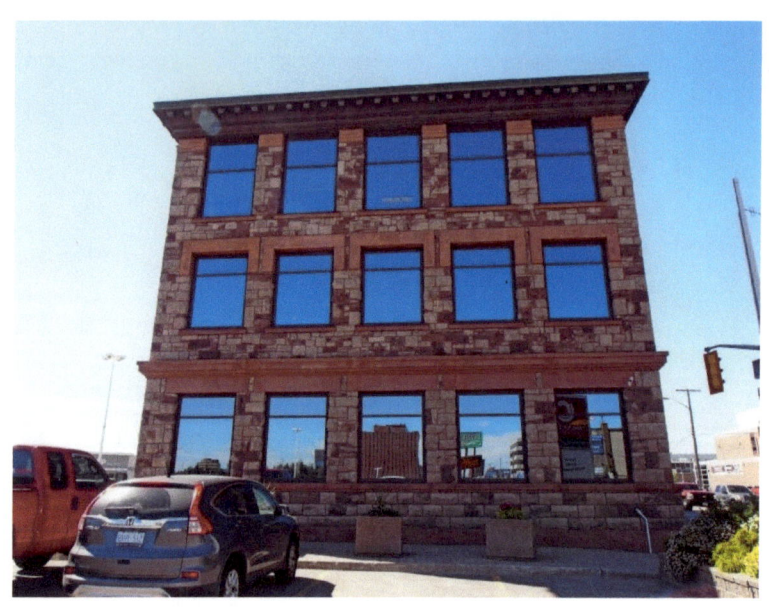

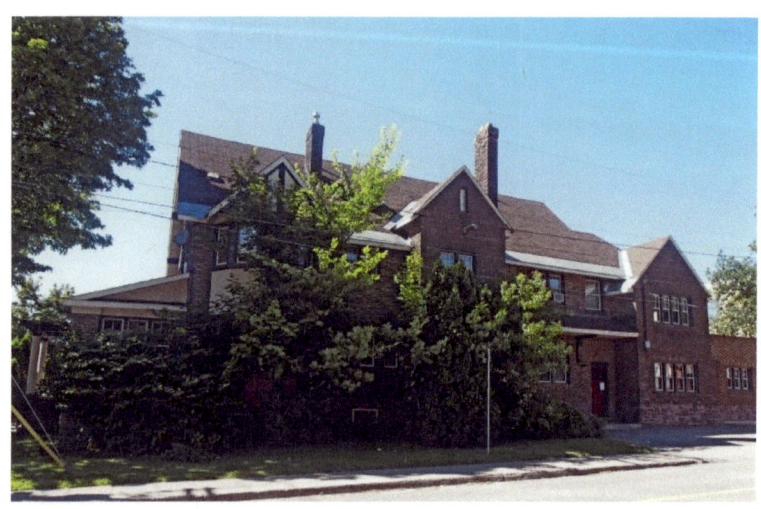

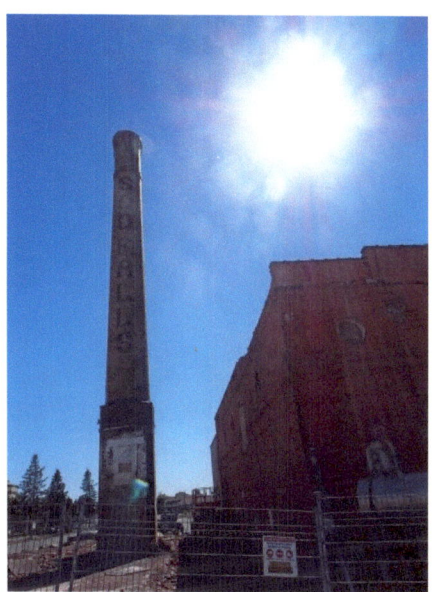

Soo Falls

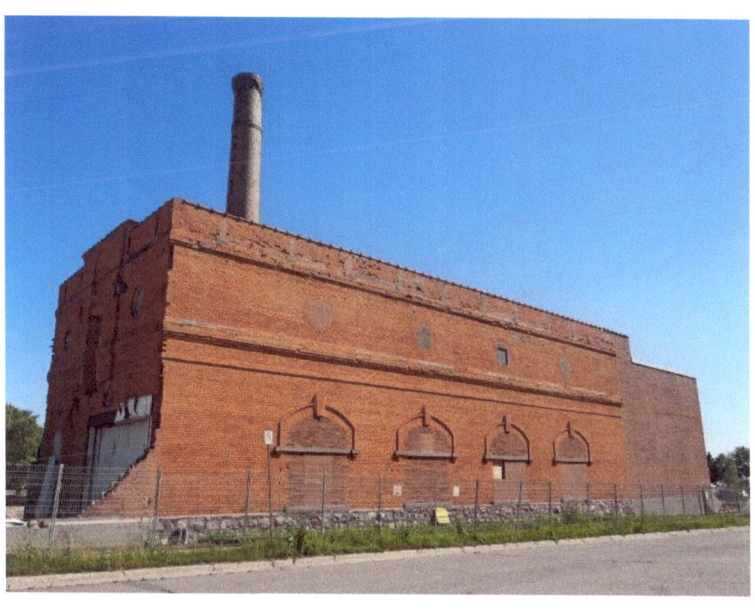

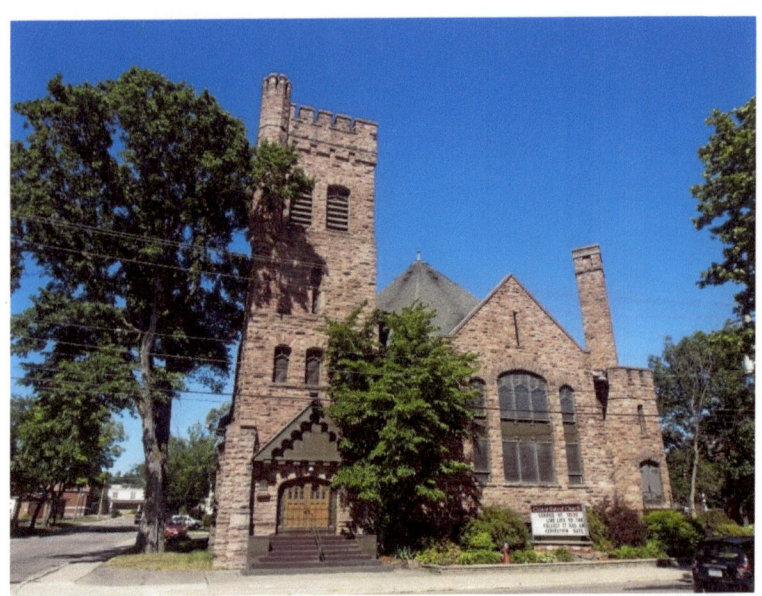
111 East Bruce Street – Central United Methodist Church

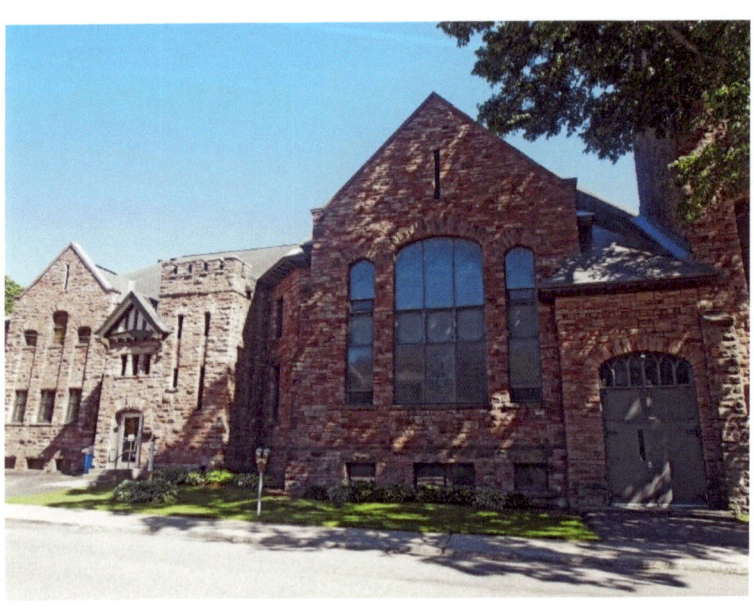

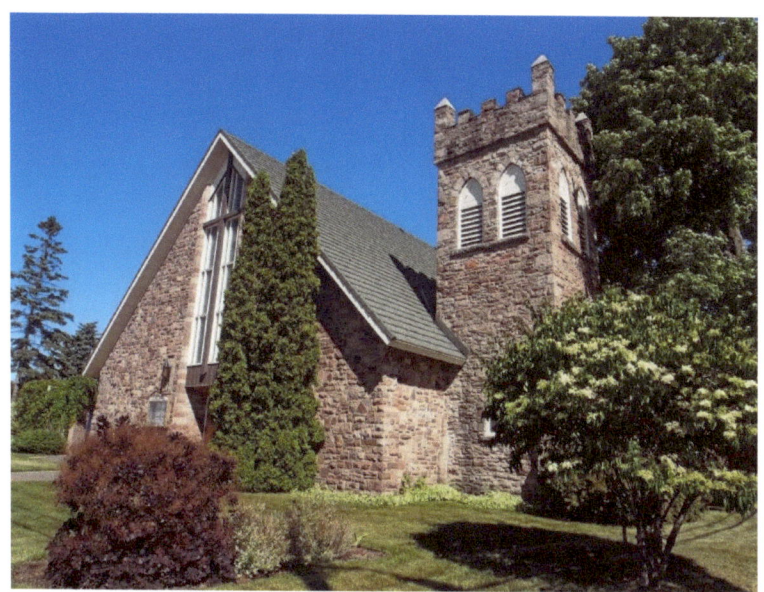

160 Brock Street – St. Luke's Cathedral (Anglican) – built in 1870

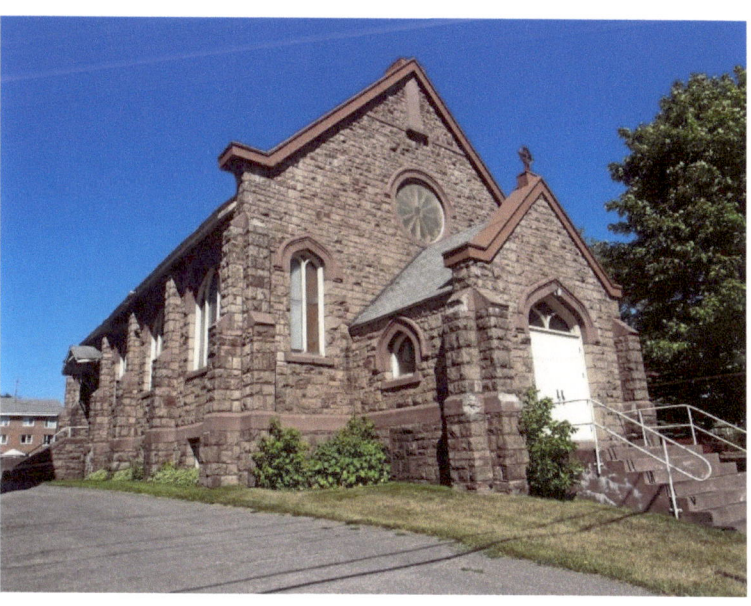

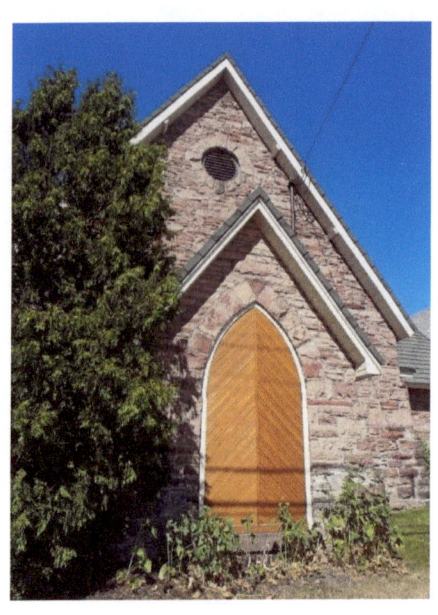

East Street – hipped roof, dormer

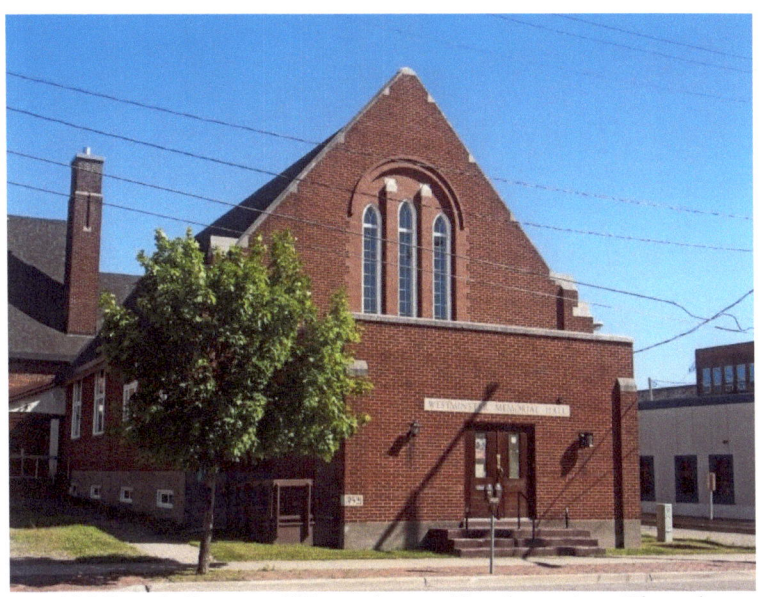

134 Brock Street – Westminster Presbyterian Church

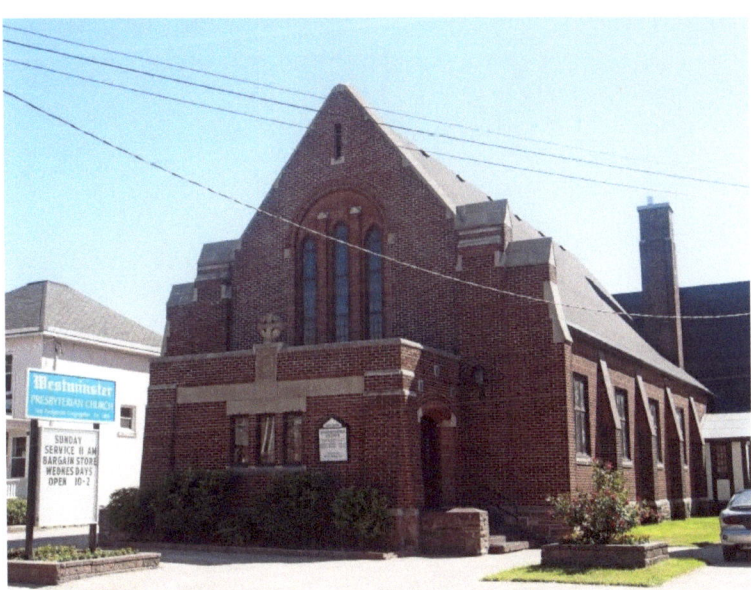

Lancet windows, buttresses

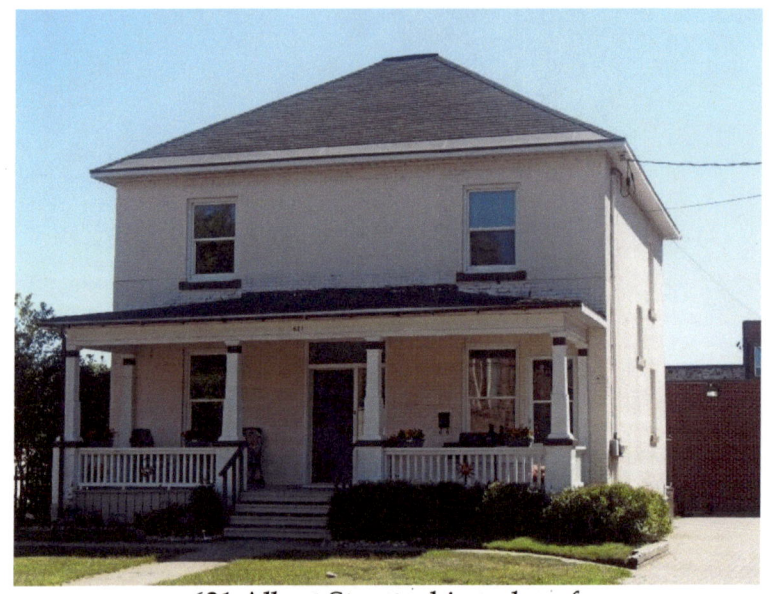

621 Albert Street – hipped roof

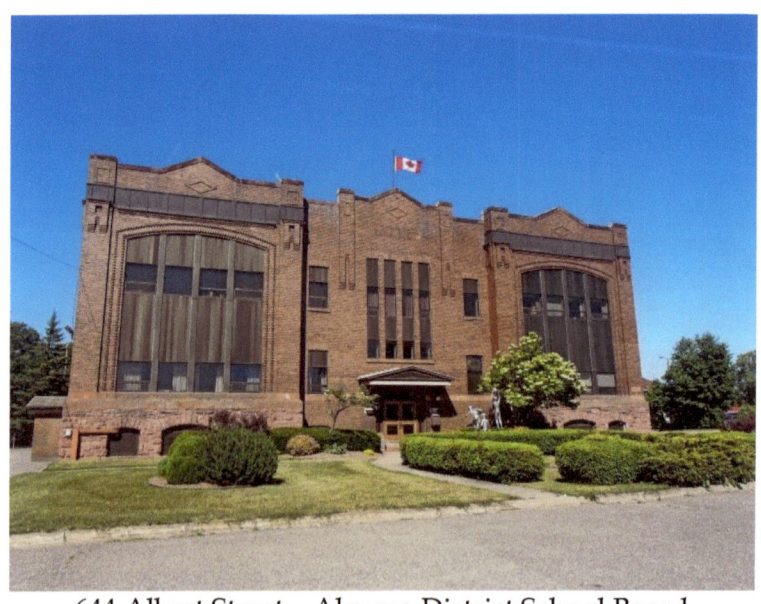

644 Albert Street – Algoma District School Board

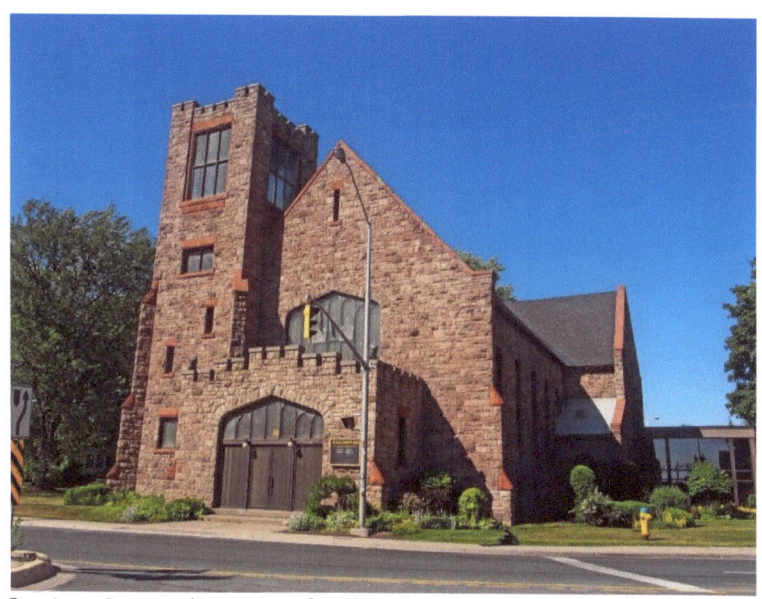

160 Spring Street (corner of Albert) - Central United Church, built in stages between 1900 and 1911, is constructed of local red sandstone. Standing on the northwest corner of Spring and Albert Streets, the church dominates the streetscape because of its size and its set-back from the street. Constructed primarily of roughly squared local red sandstone, obtained from ongoing canal excavations, the church's design was guided by nonconformist Methodist principles. Its main element is the octagonal sanctuary, a grand, vaulted space with a steeply pitched roof completed in 1903 and positioned in the southwest corner of the site, which is in sharp contrast to more common cruciform designs. The outward appearance of Central United Church does not support any one particular architectural style. Its massive appearance, conveying strength and endurance reflects the original request that the architect create a church with a style "indicative of Methodism'. It has a large, square, four-storey bell tower with decorative battlements; additional battlements are located above the front entrance. Its arched and rectangular windows of varying sizes are filled with diamond-paned leaded glass. Buttresses provide extra strength.

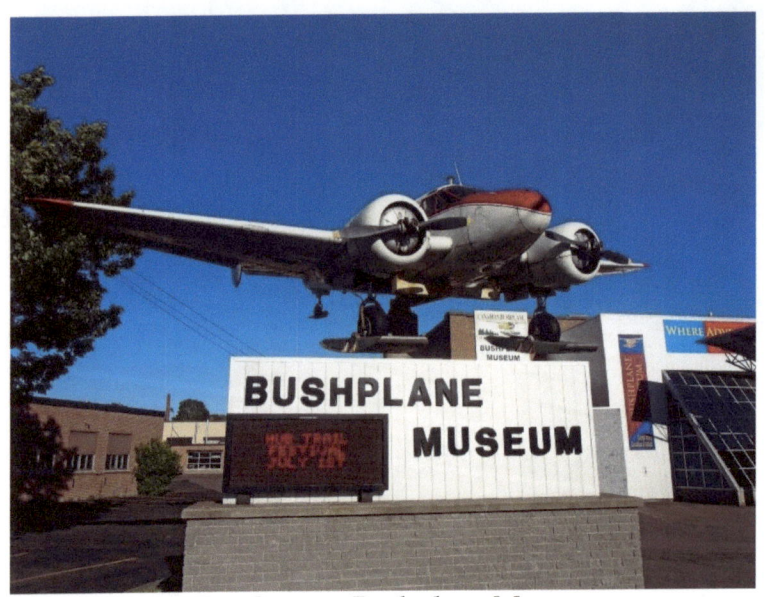
50 Pim Street – Bushplane Museum

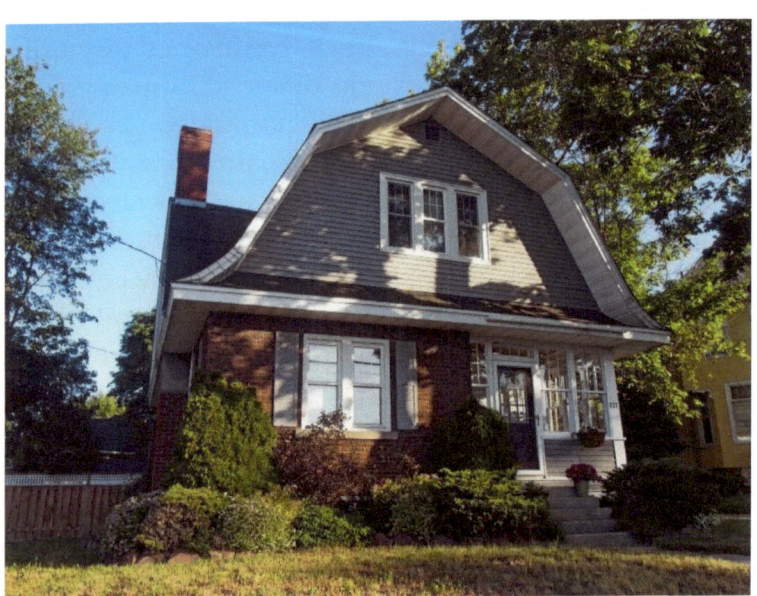
233 Pim Street – Neo-colonial – gambrel roof

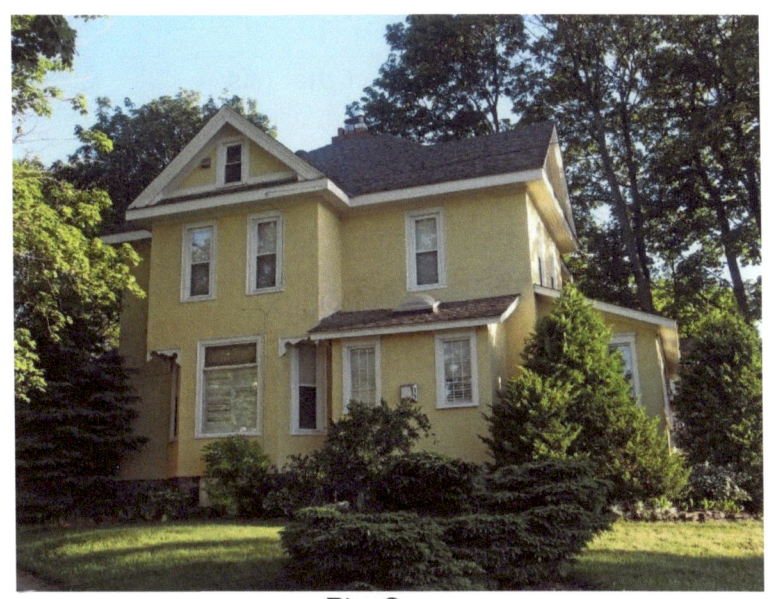

Pim Street

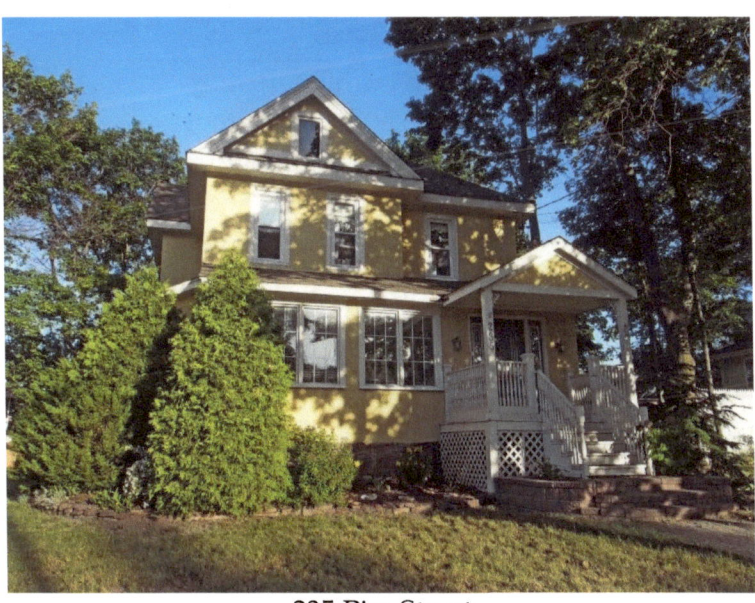

235 Pim Street

Architectural Terms

Battlement: A design for a parapet that has alternating solid parts and openings, originally used for defense, but later used as a decorative motif. Example: 111 Spruce Street, Page 51	
Bay Window: A window that projects out from a wall, in a semicircular, rectangular, or polygonal design. Used frequently in Gothic and Victorian designs. Example: MacGregor Avenue, Page 55	
Brackets: a decorative or weight-bearing structural element which forms a right angle with one side against a wall and the other under a projecting surface such as an eave or roof. Example: 358-360 Queen Street East, Page 14	
Buttress: a masonry structure built against or projecting from a wall which serves to support or reinforce the wall. In Canadian architecture, they are sometimes used for decoration. Example: 160 Brock Street, Page 53	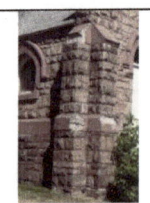
Capital: The uppermost finish or decoration on a column. An Ionic column has a small base, a thin elegant shaft, and a capital composed of volutes which are carved whirls or twists that take the form of a scroll. Example: 420 Queen Street East, Page 12	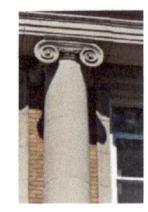

Cobblestone architecture: Refers to the use of cobblestones embedded in mortar as a method for erecting walls on houses and commercial buildings. Example: The Clergue Blockhouse, Page 42	
Cornice: originally the wooden overhang of the roof. With the use of stone, brick, iron and steel, the cornice is any horizontal moulded projection at the top of a building. They can be very decorative. Example: 736 Queen Street East, Page 27	
Dentil Moulding: an even series of rectangles used as ornamental decoration in cornices. Example: 234-246 Queen Street East, Page 19-20	
Dormer: (French for "sleep") a gable end window that pierces through the plane of a sloping roof surface to create usable space in the top floor or attic of a building by adding headroom. Example: MacGregor Avenue, Page 55	
Gable: the triangular portion of a wall between the edges of a sloping roof. Example: 1048 Queen Street East, Page 46	
Gambrel Roof: a symmetrical two-sided roof with two slopes on each side; the upper slope is positioned at a shallow angle, while the lower slope is steep. It is similar to a mansard roof, but a gambrel has vertical gable ends instead of being hipped at the four corners of the building. Example: 233 Pim Street, Page 66	

Hipped Roof: a roof where all sides slope downwards to the walls with no gables. Example: 621 Albert Street, Page 64	
Keystones and Voussoirs: a voussoir is a wedge-shaped element used in building an arch. A keystone is the central stone that locks all the stones into position, allowing the arch to bear weight. A keystone is often enlarged and embellished. Example: 358-360 Queen Street East, Page 14	
Lancet Window: a tall, narrow window with a pointed arch at its top. Example: 134 Brock Street, Page 63	
Palladian Window: a large window that is divided into three sections with the centre section larger than the two side sections and usually arched. Example: MacGregor Avenue, Page 54	
Pediment: a triangular section above the door or portico, usually supported by columns. The inside of the triangle is called the tympanum. Example: 420 Queen Street East, Page 12	
Pilaster: a slightly projecting column built into or applied to the face of a wall for additional structural support. Example: 234-240 Queen St. East, Pages 19-20	

Quoin: masonry blocks at the corner of a wall, often a decorative feature, usually larger or of a different colour than the rest of the wall. Example: 10 Kensington Terrace, Page 53	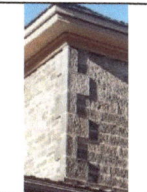
Rose Window: a circular window with ornamental tracery radiating from the centre. Example: 1100 Queen Street East, Page 43	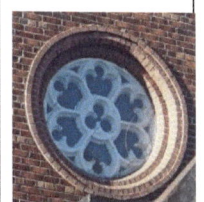
Sidelight: a vertical window that flanks a door, and is often used to emphasize the importance of a primary entrance. Example: 1033 Queen Street East, Page 47	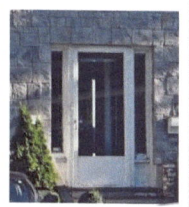
Turret: a small tower that projects from the wall of a building. Example: 3-7 Queen Street East, Page 28	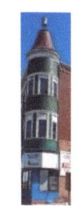
Verge board and Finial: also called bargeboards – hang from the projecting end of a roof and are often elaborately carved and ornamented. **Finial:** ornament added to the top of a gable, pinnacle, canopy or spire – a Gothic element. Example: MacGregor Avenue, Page 55	

Building Styles

Art Moderne, 1930-1945 – This style originated in the United States with rounded corners, smooth walls, and flat roofs. Large expanses of glass were used, even wrapping around corners. Example: 269 Queen Street East, Page 18	
Beaux Arts: Promoters of this style sought to express the classical principles on a grand and imposing scale. Many of the Beaux Arts buildings were banks, post offices, and railway stations. The Ontario Beaux Arts style is eclectic mixing elements of Classical, Renaissance and Baroque. Often the designs have a temple-like façade, porticos with pediments, balustrades, and capitals in many styles. Example: 420 Queen Street East, Page 12	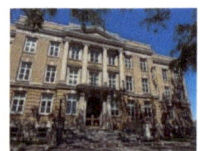
Classical Revival, 1820-1860 – This style was an analytical, scientific, and dogmatic revival based on intensive studies of Greek and Roman buildings, concerned with the application of Greek plans and proportions to civic buildings. Schools, libraries, government offices, and most other civic buildings were built in the Classical Revival style. The white columned porches of the Classical Revival domestic buildings are identified with the mansions of wealthy land owners in Canada. Example: 358-360 Queen Street East, Page 14	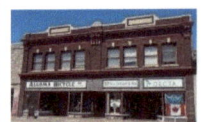

Federalist, 1780-1820s: Identifying features of the federal colonial house plans include a fanlight over the front door with or without sidelights. The fanlight is usually a semi-circular or elliptical shape. The front door is often emphasized with decorative moldings. The windows are double-hung sashes with six panes per sash and are aligned horizontally and vertically in a symmetrical pattern on the front facade. The windows are never in pairs; however, Palladian style windows in three parts are common above the front door. The roofs are mostly hipped and can be seen gabled as well. Federal style house plans are commonly seen with and without covered entries. Example: 690 Queen Street East, Page 30	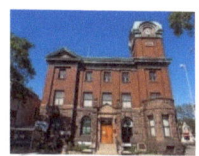
Edwardian, 1900-1930 – This style bridges the ornate and elaborate styles of the Victorian era and the simplified styles of the 20th century. Edwardian Classicism provided simple, balanced facades, simple rooflines, dormer windows, large front porches, and smooth brick surfaces. Voussoirs and keystones are used sparingly and are understated. Finials and cresting are absent. Cornice brackets and braces are block-like and openings have flat arches or plain stone lintels. Example: 668 Queen Street East, Page 37	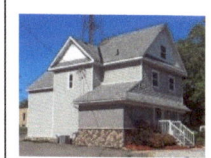

Georgian, before 1860 – This style began with the British King Georges in the 18th century. These buildings have balanced facades around a central door, medium-pitched gable roofs, and small paned windows. Example: 831 Queen Street East, Page 41	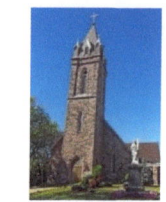
Gothic Revival, 1830-1890 – These decorative buildings have sharply-pitched gables with highly detailed verge boards, pointed-arch window openings, and dichromatic brickwork. It is a common style in Ontario. Example: 778 Queen Street East, Page 35	
Neo-colonial (also Colonial Revival, Georgian Revival or Neo-Georgian) architecture seeks to revive elements of architectural style of American colonial architecture of the period around the Revolutionary War which drew strongly from Georgian architecture of Great Britain. Architecture from the 18th and early 19th centuries in Ontario includes a wide assortment of detailing and ornament applied to a design centered around the fireplace and the source of water. Structures are typically two stories, have a symmetrical front facade with elaborate front doorways, often with decorative crown pediments, fanlights, and sidelights, symmetrical windows flanking the front entrance, often in pairs or threes, and columned porches. Example: 233 Pim Street, Page 66	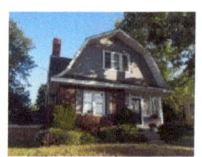

Queen Anne, 1885-1900 – This style is distinguished by an irregular outline featuring a combination of an offset tower, broad gables, projecting two-storey bays, verandahs, multi-sloped roofs, and tall, decorative chimneys. A mixture of brick and wood is common. Windows often have one large single-paned bottom sash and small panes in the upper sash. Example: 115 Upton Road, Page 44	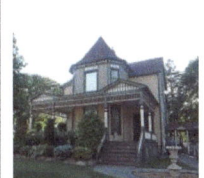
Richardsonian Romanesque Revival, 1870-1910 – is a style of Romanesque Revival architecture which incorporates 11th and 12th century southern French, Spanish and Italian Romanesque characteristics. It emphasizes clear, strong picturesque massing, round-headed Romanesque arches which often spring from clusters of short squat columns, recessed entrances, richly varied rustication, blank stretches of walls contrasting with bands of windows, and cylindrical towers with conical caps embedded in the walls. Example: 75 Huron Street, Page 7	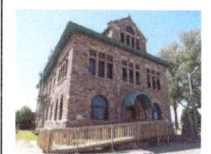
Romanesque Revival, 1880-1910 – This style hearkens back to medieval architecture of the 11th and 12th centuries with a heavy appearance, blocky towers and rounded arches. Example: 242-246 Queen Street East, Page 19	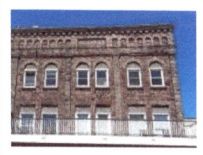

Second Empire, 1860-1880 – The mansard roof is the most noteworthy feature of this style and is evidence of the French origins. Projecting central towers and one or two-storey bays can also be present. Example: 34-36 Herrick Street, Page 51	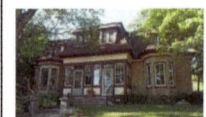
Tudor Revival – exposed timbers with stucco infill, multi-paned windows. Example: 1129 Queen Street East, Page 48	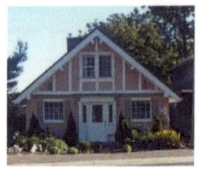
Victorian - In Ontario, a Victorian style building can be seen as any building built between 1840 and 1900 that doesn't fit into any of the other categories. It encompasses a large group of buildings constructed in brick, stone, and timber, using an eclectic mixture of Classical and Gothic motifs. Example: 3-7 Queen Street East, Page 28	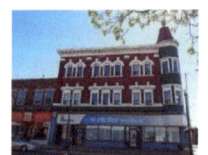

www.ingramcontent.com/pod-product-compliance
Lightning Source LLC
Chambersburg PA
CBHW041104180526
45172CB00001B/96